HAUNTED PRESCOTT

HAUNTED PRESCOTT

PARKER ANDERSON & DARLENE WILSON

Haunted America

Published by Haunted America

A Division of The History Press

Charleston, SC

www.historypress.com

First published 2018

Manufactured in the United States

ISBN 9781467141222

Library of Congress Control Number: 2018943598

CONTENTS

ACKNOWLEDGEMENTS

We want to thank Sharlot Hall Museum Library and Archives for information and pictures used in this book.

Thanks to Cindy Gresser and Manuel Lucero from the Smoki Museum for the fascinating stories of this beautiful place.

Thanks also to Colette Greenlee and Jennifer Ward from the Elks Opera House and Performing Arts Center for their amazing historical and haunted stories.

We want to thank Zoe Brown and Katelyn Dugan at the Hotel Vendome for their assistance, as well as Spencer and Amore at the Hassayampa Inn. Thank you to Hotel Vendome and Hassayampa Inn for allowing coauthor Wilson to bring groups of people through your lobby on her Haunting Experience Tours.

Thanks to the folks at the historical Palace Saloon for their stories and photographs, as well as for allowing coauthor Wilson to bring groups of people in your saloon and dining room from her tour.

Special thanks to Gregg Michelson, LeighAnn Fleenor and Rhea Formoso, as well as the other employees at Einstein Brothers Bagels shop in Prescott. They always have a warm smile and friendly attitude and save my favorite corner table to work on this book.

Thanks to Isabelle Barnes-Berutts for sharing her pictures of Old Prescott. She is part of a private group called Long-Time Residents of Prescott and has the best photos and stories of this amazing town.

Thanks to Shane Phipps, coauthor Wilson's son, for his pictures he took for the book and support in writing this book. He's a great son to travel with around town to get the photos needed for this book.

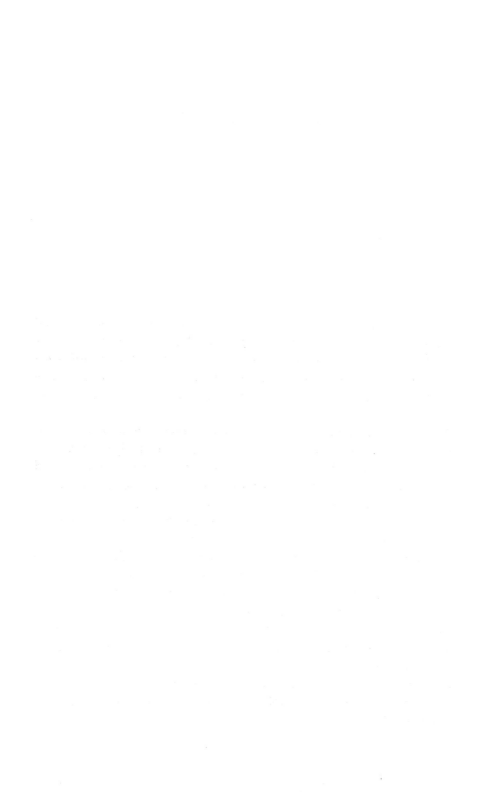

INTRODUCTION

What happens to us after we die? This is a question that mankind has been asking since the beginning of time, and there has never been a consensus of opinion. The belief in what occurs following death has differed from culture to culture, from time to time, with the only consistency being that we do have an immortal soul that goes *somewhere* after our inevitable demise.

So, what about ghosts? A ghost is "an apparition of a dead person that is believed to appear or become manifest to the living, typically as a nebulous image." And spirits? They are "the nonphysical part of a person manifested as an apparition after their death; a ghost; a supernatural being." Your spirit is the part of you that is not physical and that consists of your character and feelings. A person's spirit is their nonphysical part that is believed to remain alive after death.

Descriptions of ghosts vary widely, from an invisible presence to translucent or barely visible wispy shapes, realistic lifelike visions or even orbs that appear in photographs. Orbs are likely not spirit beings in and of themselves, but rather emanations from spirit beings. Or they could be dust particles flying around the room. You have to be aware of your surroundings to decide what the orb is that appears in your pictures. If it is a spirit/ghost, it is much easier (as in it doesn't take as much energy) for a spirit/ghost to appear as an orb rather than as a more complete and complex presence. (Note to photographers: orbs will often respond to requests to appear in photographs.)

Many believe that ghosts are indeed the spirits of the dead, remaining behind in a place they loved in life. Others believe that these spirits are trapped in some kind of vortex because they died horrible deaths on a particular property. Still others believe that the ghosts are not related to the property at all but have settled there because they like it. All of this could be true. It is unlikely that one explanation covers every lingering spirit. The reasons could be as varied as the spirits themselves.

Ghost sightings and haunted places are so widespread that virtually every sizable town and city has them. What is responsible for these phenomena is a matter of debate. There are many differing opinions as to the meaning of ghosts, spirits and what happens after we die. My advice is to read everything you can on any paranormal subject you are interested in and then form your own opinion. Don't believe everything you read or hear. You will know what feels right for you.

The purpose of our book is to relate some of the stories of the ghosts of Prescott, along with some information on the history of our fascinating city.

Jack W. (Jack) Swilling (1830–1878) led the first party of non-Indians to explore the Hassayampa River in January 1860. He and his companions declared that "this new region has the finest indications of gold of any they have ever seen." In 1867, Swilling began the first canal building company in the Salt River Valley, leading to the beginnings of Phoenix and surrounding communities.

PRESCOTT, ARIZONA

President Abraham Lincoln signed the Organic Act on February 20, 1863, creating the Arizona Territory out of a portion of land that had been ceded by Mexico to America by force at the end of the Mexican-American War (1846–48). This required the president to appoint a set of officials and send them west to set up a new territorial government for Arizona. Initially, he appointed Ohio congressman John Addison Gurley to be governor of the new territory, but he unexpectedly died of an appendicitis attack before the party set out. On the recommendation of Richard McCormick, President Lincoln then appointed former Maine congressman John Noble Goodwin to the post. McCormick was appointed secretary of the territory.

The first Governor's Party set out for its destination, traveling overland by coach—a long and arduous journey indeed. The party members were informally expected to set up the new capital at Tucson, an old Mexican pueblo that was the only real town of any size in the new Arizona Territory. After crossing into Arizona in December 1863, Governor Goodwin was informed by General James H. Carleton that Tucson was believed to be a hotbed of Confederate sympathizers (the Civil War was still going on at this time) and that this could make it a difficult place for a new Yankee government to set up shop. The Confederacy had already made a failed attempt to claim Arizona for itself.

The party stopped at Fort Whipple (then located at Del Rio Springs, which is somewhat north of Chino Valley) to get its bearings and decide what to do next. After much scouting and debating, it traveled farther south of Fort Whipple and camped on the banks of Granite Creek. This area was inhabited by only a few stray miners and settlers, but the Arizona territorial officials decided this was the place to establish Arizona's first capital. They christened the new town Prescott, named after the famed Boston-based historian William Hickling Prescott, who had died five years earlier. Naming a new town in honor of a man who had never set foot near the area was likely reflective of the New England dominance of the members of the Governor's Party—throughout the East Coast, William Prescott was held in very high regard at this time.

Joseph R. Walker (1798–1876) played a dramatic half-century role in the opening of the American West. Beginning as a fur trader and trapper, and then as an explorer and guide, he was one of the great pathfinders across the unknown portions of the United States. This famous frontiersman was on his last great adventure "into the only unknown section of the United States" when he led a party of fortune seekers to this undeveloped area.

Prescott was destined not to stay the capital, but the town remained and prospered. Its main source of industry and economic growth was mining, as would become true throughout much of Arizona. The territory was finally granted statehood in 1912, becoming the forty-eighth state, but mining started to die out throughout Arizona in the mid-1930s—and Prescott was no exception.

Today, Prescott is a thriving metropolitan city with a population of more than fifty thousand, not counting the neighboring

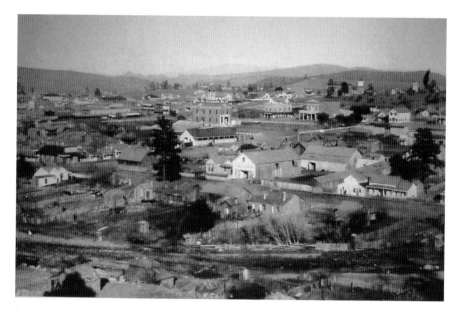

Downtown Prescott, 1900s. *Courtesy of Isabelle Barnes-Berutto.*

cities of Prescott Valley and Chino Valley, which are almost as large. The growth of Prescott and its surrounding areas, most notable within the last thirty years, has been remarkable, quadrupling in size during that period. Prescott is largely a retirement community today, with an economy based almost entirely on land development and tourism. Prescott lays claim to hosting the world's oldest annual rodeo, held every summer since 1888.

Prescott is located in north-central Arizona in Yavapai County, surrounded on almost all sides by forest and mountains. Its city limits extend far beyond what they were even in the latter twentieth century. But downtown Prescott, where visitors usually want to go, remains old and rustic. Thousands utilize the Courthouse Plaza every year, and the current courthouse remains the county seat of Yavapai County.

Needless to say, it is the old part of town, which has been here since the beginning of Prescott, that has had most of the city's ghost sightings and haunted houses. Let us go downtown and explore them.

HISTORICAL MARKER: PRESCOTT

The City of Prescott had its beginnings in the Spring of 1863 when a party of explorers and would-be gold miners led by the famed Joseph R. Walker arrived near the headwaters of the Hassayampa River. On May 10, 1863, at a location some six miles south-southeast of this Plaza, twenty-five members of the Walker Prospecting and Mining Company adopted "Laws and Resolutions" governing members of the first mining district in what would later become Yavapai County. The rules for the "Pioneer Mining District" provided a foundation for the establishment of mining law in the central Arizona highlands, and can be considered Prescott's birth certificate.

Thus began a gold rush that sparked the settlement and development of central Arizona, and the choice of Prescott as the first Territorial Capital. Before then, this area was almost totally unknown to white men, and gold mining prospects had been known only along the Colorado and Gila Rivers.

Joseph R. Walker led this group of explorers and miners on an expedition that started in California and went through portions of Northern Arizona, Colorado and New Mexico before ending here two years later. John W. (Jack) Swilling joined the party in New Mexico and then guided them to where he had seen significant indication of gold three years earlier.

The other twenty-three members of the "Original Prospectors" listed in their organizational document were: Joseph R. Walker, Jr., John Dickson, Jacob Linn, Jacob Miller, James V. Wheelhouse, Frank Finney, Sam Miller, George Blosser, A.C. Benedict, S. Shoup, T.J. Johnson, Daniel Ellis (Conner), Abner French, Charles Taylor, H.B. Cummings, William Williams, G. Gillalan, Jackson McCrackin, Rodney McKinnon, Felix Cholet, M. Lewis, James Chase, and George Coulter.

When the company was officially disbanded six months later, Captain Walker noted with satisfaction that: "We opened the door and held it open to civilization and now civilization will do the rest."

WHISKEY ROW

THE COURTHOUSE PLAZA

Known as the "jewel" of downtown Prescott ever since the 1880s, the Courthouse Plaza has been a gathering place and is the center of town. The first or original courthouse, built on July 1, 1867, was constructed on leased land just northeast of the plaza, where the Masonic Temple now stands. According to *Prescott: A Pictorial History* by Melissa Ruffner, the building housed the jail and Sheriff's Office on the ground floor and a community meeting hall/courtroom on the second floor. Legal executions were carried out in the fenced yard behind the courthouse. Early church services were held here, and in later years, it became the Bellevue Hotel.

The second courthouse was built in 1878 with a basement, two stories of red brick and a clock tower with a bell. It was torn down in 1916 when it began to crumble. It was decided that a much bigger building was needed. The last of the hangings took place on the plaza.

The third courthouse started construction in 1916; built of Prescott granite, the interior was reinforced concrete. The eight-hundred-pound bell from the old courthouse was installed as well.

In 1881, four wells were installed on the four corners of the plaza. All the wells are gone except the one located on the southeast corner of the plaza. It's twenty-seven feet deep; it has no water, but it's very interesting. There is a light in the well, and you can see the original rock walls and wooden planks.

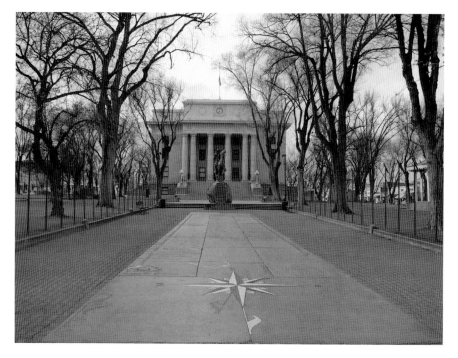

Prescott's Courthouse Plaza. *Courtesy of Darlene Wilson.*

Many people walk right past this area, having no idea that this amazing well is behind the small black wrought-iron fence.

Today, the Yavapai County Courthouse is a large, pillared facility situated squarely in downtown Prescott. Constructed in 1916, it was once the center of town. It is surrounded by Montezuma Street on the west side, Gurley Street on the north, Cortez Street on the east and Goodwin Street on the south side. The plaza around the courthouse consists of grassy areas, benches, a gazebo, a fountain and three statues, including a 1907 original by sculptor Solon Borglum that pays tribute to the Rough Riders Memorial. Fifty years later, in Prescott, Arizona, U.S. stamp no. 973 was issued to commemorate the fiftieth anniversary of the formation of the Rough Riders.

Prescott was named "Arizona's Christmas City" in 1989 by the governor, with more than one hundred trees sparkling with nearly 1 million holiday lights, as well as courthouse lights and abundant festive holiday activities.

Prescott's existing bandstand dates back to 1910, but the first bandstand was built in 1880, when brass bands were performing on the plaza. The original bandstand survived the Great Fire of 1900 and was used as a

Second courthouse. *Courtesy of Isabelle Barnes-Berutto.*

barbershop after the business district burned down. Today, the bandstand, the "Grand Lady," is still here. You will see children playing games in the bandstand or just hanging out. Music on the plaza can be heard coming from the area. We think the band still plays on at this historical bandstand. As of this writing, a memorial is being designed to honor the nineteen members of the Granite Mountain Hotshots who lost their lives on June 30, 2013, when the Yarnell Hill Fire they were battling overran them in the deadliest wildfire in Arizona history.

To this day, citizens of Prescott and tourists alike walk the plaza every day to relax, watch people go by, visit with one another and walk their dogs. Virtually all of Prescott's best-known haunted sites are within walking distance from the Courthouse Plaza, so we will begin here.

HISTORICAL MARKER: PLAZA BANDSTAND

As early as 1865, Lucian Bonaparte Jewell organized a Brass Band in Prescott, but by the 1870s the regimental bands from Ft. Whipple began to dominate the local music scene. The original Plaza Bandstand, built in the late 1800s, had survived the fire of 1900, but was eventually removed. On July 8, 1908, The Prescott Brass Band was reorganized and showed interest in erecting a permanent ornamental Bandstand on the Plaza. It was not until May 1910, that Henry Rockmark was awarded the contract for construction of the new Bandstand for the sum of $1,150.00. The Summer of 1910 was a special time for the AZ Territory with the passage of the statehood bill by the US Congress, June 19, 1910. Territorial Governor Richard E. Sloan was the honored guest for the Statehood and Fourth of July celebration several weeks later. From the new Bandstand, the Prescott Concert Band, in their handsome new uniforms from the East, struck up the tune "Hail to the Chief" and the Governor delivered the dedication address for the planting of the Statehood Tree. This was the first official ceremony from the new Bandstand. The Bandstand pre-dates the present Courthouse and has been the site for weddings, Sunday schools, and Christmas ornamentations. It remains much as it was constructed in 1910, with the exception of the original wood railings which were replaced with iron railings.

In celebration of the Plaza Bandstand Centennial
Granite Mountain Questers, 2010

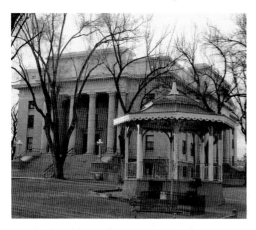

Courthouse and gazebo.
Courtesy of Darlene Wilson.

HANGINGS IN PRESCOTT

When people think of hangings, they usually envision a mob lynching—someone is either kidnapped or broken out of jail by an angry group of men taking the law into their own hands. But in truth, hanging was the legal mode of execution in America—and throughout much of the world—until the invention of the electric chair. If you were tried and sentenced to death in the nineteenth and early twentieth centuries, you were hanged.

In those days, legal hangings usually took place in the county where the crime had taken place, with the sheriff presiding over the proceedings. Executions started to be moved to the state or territorial prisons only in the early twentieth century. Consequently, there were eleven legal hangings in Prescott between 1875 and 1925. The earliest ones took place in the yard of the police headquarters—it is unclear exactly where this was located, but it was almost certainly right downtown in a secluded area. The later hangings were carried out on the east side of the Courthouse Plaza. Because these men met their own deaths in such a violent manner, some have wondered if it might be some of their spirits that are haunting the downtown buildings, especially the buildings where nothing is known to have happened that might otherwise spur such hauntings. Following are Prescott's legal hangings:

- Manuel Abiles was tried, along with two other men who were let off, for the murder of a guest at a "Mexican weddding" near the town of Camp Verde. He was convicted and sentenced to death. He was hanged in the police yard on August 6, 1875. A popular but untrue legend contends that sixty years later, an old man on his deathbed confessed to the murder, exonerating Abiles.
- In 1876, army private James Malone was accused of the murder of another private, Richard Lawler, at Fort Mojave, far northwest of Prescott. Malone was brought to Prescott for trial; it is unclear why the army turned him over to the civil authorities instead of court-martialing him. Malone was sentenced to die and was hanged in the Prescott jail yard on March 15, 1878. Four years later, in a bizarre twist, his skeleton was stolen from a medical school and left at the fountain on the Courthouse Plaza, apparently as a practical joke.
- On February 3, 1882, John Berry was hanged after being convicted of the murder of a rancher named Michael "Old Tex" Shores at the mining town of Tip-Top (now a ghost town).

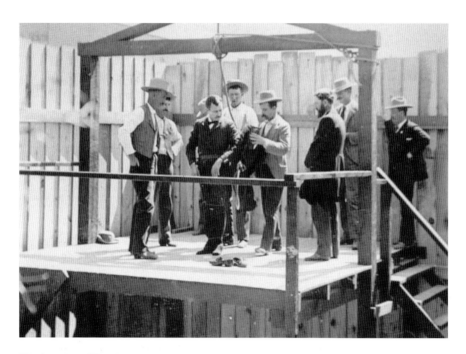

The hanging of Fleming "James" Parker in Courthouse Plaza. *Courtesy of Isabelle Barnes-Berutto.*

- On February 10, 1882 (only one week after the execution of John Berry), Henry H. Hall was hanged in the jail yard for the murder of a Flagstaff saloon owner while on a drunken spree.
- On December 20, 1885, a ranch hand named Dennis W. Dilda shot and killed Yavapai County deputy John Murphy, who had come to arrest him on a theft charge. Dilda was later connected to the murder of another ranch hand named James "General Grant" Jenkins, with motive unknown. Tried and convicted, he was hanged on February 5, 1886, only forty-seven days after killing Deputy Murphy. Dilda left behind a wife and two small children.
- In 1886, ranchers Samuel and Charlotte Clevenger were murdered by two of their hired hands, Frank Wilson and John A. Johnson, while traveling near the Arizona/Utah line. Brought to Prescott for trial, both men were sentenced to death. Johnson received a last-minute reprieve, but Frank Wilson (who claimed that his name was an alias but refused to give his real name) was hanged on August 12, 1887.

- On March 2, 1888, Martin Duran was hanged for the murder of his ex-lover, Reyes Baca. He was the only one of Prescott's hangings to go to the gallows for the murder of a woman.
- In 1897, a Northern Arizona outlaw named Fleming "James" Parker robbed a train on the Yavapai/Mohave County line. Brought to Prescott to await trial, he and two other men broke out of jail and secured arms. On their way out, Parker gunned down Yavapai County deputy district attorney Lee Norris. After eluding a horseback posse for nearly three weeks, Parker was recaptured and convicted of murder. He was hanged on June 3, 1898, on the Courthouse Plaza, with legendary sheriff George C. Ruffner (who had once been a friend of Parker's) pulling the switch. This remains one of Prescott's best-known historical stories.
- Prescott saw its first double hanging on July 31, 1903, when Hilario Hidalgo and Francisco Renteria were hanged on the Courthouse Plaza for the murders of Charles Goddard and Frank Cox, who owned a stage stop near what is today Black Canyon City.
- Prescott's final hanging was actually a federal execution at Fort Whipple, a military base about three miles from downtown Prescott. On October 10, 1925, George Dixon Sujynamie, a Hualapai Indian, was hanged for the murder of Albert Cavell, a Prescott taxi driver.

Is it possible that the spirits of any of these troubled men are haunting downtown Prescott?

FIRES

On July 14, 1900, one small candle, lit by a miner, caused the Great Fire of Prescott—or so the story goes. The miner was staying in the Scopel Hotel, located on the corner of Goodwin and Montezuma Streets. This is the story that is accepted by many, although there was no proof. The fire chief testified that it was a mystery, but the miner story is still the one you hear around town.

However the fire started, it destroyed eight blocks of Prescott, burning down businesses that were mostly made of wood; the Prescott winds drove

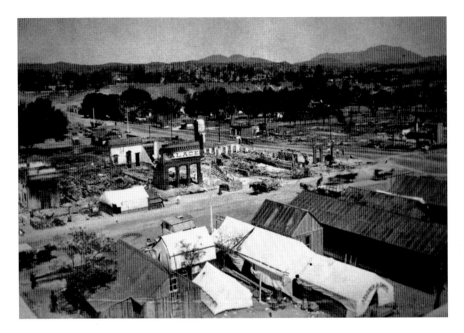

Downtown Prescott after the Great Fire. *Courtesy of Isabelle Barnes-Berutto.*

the fire quickly through downtown. Volunteer firemen rushed with hose carts to put out the flames, but it was too late.

At the famous watering hole the Palace Saloon, customers who were drinking at the bar picked up the bar itself and carried it across the street to the Courthouse Plaza; there they continued drinking while the town burned down. The bar you see today at the Palace Saloon is the original bar that came over in a covered wagon in the late 1800s. Another saloon's customers carried the piano across the street to the Courthouse Plaza. Others grabbed what they could and fled for their lives. One barber took his barber chair and tools and moved everything to the Courthouse Plaza.

We heard they saved all the liquor in town and were open for business in the plaza the next day. The barber continued giving shaves and haircuts, a bartender served drinks and the piano was playing constantly. Soon they started putting up tents and tin shacks to keep business going while the town rebuilt.

The loss was estimated at $1.5 million; while almost none of the merchants had insurance, almost all of them rebuilt. Although a very destructive fire, no one died, and Prescott emerged a more beautiful city. Most of the buildings that were built after the fire are still standing.

HISTORICAL MARKER: THE FIRE OF 1900

A disastrous fire on the night of July 14, 1900 changed the face of downtown Prescott. Starting in a room in the Scopel Hotel on the southwest corner of Goodwin and Montezuma Streets, the fire quickly hopped across Goodwin Street and proceeded to consume all of the buildings on "Whiskey Row" leveling the entire block. Though some of the Plaza buildings were built of brick, many were wood, and the destruction was nearly complete. The fire burned almost everything in its path to Granite Creek and Willis Street, a total of over 80 businesses. Prescott had suffered fires before, but this was by far the worst. The pluck and courage of its merchants and residents was evident, however, as they pitched in to rebuild, this time of more substantial means: brick, concrete, and stone. Within three days construction was underway. Undaunted merchants were open and doing a brisk business in tents, corrugated metal buildings, and hastily constructed sheds on the courthouse lawn. Of the buildings standing at the time of the fire, only a few remain: The Prescott National Bank and the Bank of Prescott (both under construction in 1900), the Knights of Pythias Building on South Cortez Street, and the City Jail and Fire Station on West Goodwin Street.

Funded by the Historic Preservation Fund and the City of Prescott

There are many stories of spirits seen around the courthouse, and apparitions have been seen on the steps. On one of my tours, we were standing around talking about the hangings that took place in the plaza when someone in the group got tapped on the arm. It didn't really scare them, but they were a little unnerved by the experience. I think some of the spirits that celebrated the fire are still hanging around partying on the plaza.

GRANITE STREET

What's so special about this parking structure? Maybe it's not what it is *now* but rather what it used to be that's important. From the late 1860s until the Great Fire of 1900, this area was home to two very different communities of citizens: the Chinese community and the red-light district.

The first known local record of prostitution was in 1868. Lydia Carlton was Prescott's most well-known madam; she had a two-story house that featured bedrooms and social rooms and charged twice as much as the other brothels. All customers were required to be inspected for venereal disease prior to doing business with the ladies.

In 1900, the City of Prescott instituted an ordinance prohibiting prostitution outside prescribed limits. Business was so good that in 1913, the city added forty lots to the red-light district. In 1918, authorities at Fort Whipple gave official orders to close the red-light district. Prostitution after that went underground and continued to flourish in smaller numbers until 1947, when the county attorney eliminated prostitution altogether.

One interesting note discovered was how the prostitutes were treated with respect by the press and the townspeople. One article written by the press of the death of one of the prostitutes noted that she was "a lady of easy virtue." The *Miner* publisher, John H. Marion, made sure that all articles regarding the deaths of prostitutes were always done with respect and sympathy. After the second death of the prostitute, territorial governor A.P.K. Safford offered a $500 reward for information leading to the arrest and conviction of the criminal. At that time, the capital had moved south to Tucson, yet the governor still considered the case important.

The Chinese arrived in the late 1860s, and the newspaper reflected the popular opinions that showed negative attitudes toward the Chinese groups. After completing the building of the transcontinental railroad, they arrived in Prescott and became produce farmers, miners, cooks, laundry workers and domestic servants. Many things contributed to the departure of the Chinese, and in 1886, a man started a campaign against the ethnic group. Also, Granite Creek flooded and washed out Chinatown. In 1914, with Prohibition came the closing of restaurants, saloons, hotels and other businesses, so many Chinese residents found themselves without jobs.

With the Depression and Prohibition, those buildings on Granite Street fell into decay, and that area stayed empty for years. In 2002, it was decided to build a parking structure on the empty lot, and because federal money was involved, city officials reluctantly agreed to an archaeological survey.

Granite Street parking structure. *Courtesy of Darlene Wilson.*

SWCA (a nationwide environmental consulting firm) was put in charge of the archaeological dig, and artifacts recovered were associated with prostitution and the Chinese people who lived and worked on Granite Street.

SWCA identified a two-story brothel and privy in that area. Most of the artifacts are associated with a variety of alcoholic beverages and the maintenance of prostitution, gambling and opium dens. They also dug up bottles of Batchelor's Liquid Hair Dye No. 2. Several pieces of fine English china or porcelain, indicating that these prostitutes were not at the bottom of the barrel, were also discovered. There was a kind of hierarchy of prostitution, from brothels to boardinghouses to cribs. Archives at the Sharlot Hall Museum contains photos of the cribs along Granite Street, as well as pictures of Chinatown.

Because of decades of activity in that area, strange and ghostly things have happened in that parking structure, such as sounds when no one else is around. One person said she won't park there anymore because she feels like she's being watched and is uncomfortable. They were just doing construction on the parking structure, and that can definitely stir up any ghosts in the area.

TUNNEL LEGENDS

One of Prescott's most enduring legends is rather eerie, though not necessarily ghostly. According to folklore, there is a maze of underground tunnels beneath downtown Prescott, stretching all the way from Granite Street (behind Whiskey Row) to North Marina Street.

Prescott had a large population of Chinese immigrants in the late nineteenth and early twentieth centuries, and according to the legends, they were the ones who secretly carved out and built these huge tunnels. Folklore fails to give them a motive for doing this, but according to some storytellers, it was because they were not allowed to move around town outside of their neighborhoods and this was their way of getting about. Still others claim that they were going to use the tunnels to launch a surprise uprising against whites in Prescott at some future date.

There is no evidence to support the existence of the Chinese tunnels in Prescott, but the legend refuses to die. Whenever it is brought up, there are always local residents who speak up and swear that they have been inside them, explored them and taken pictures and video of them. Some claim that they have been chased out of them by the police, who warn them they had better keep quiet or else. Can we believe them? It is difficult to do so because, to date, all the alleged witnesses (and there have been many) have failed to produce any photos or video images, and they have found excuses for why they are unable to tell us where the entrances are and how they got in.

Adherents of the tunnel legends also claim that the Prescott city government has long been engaged in a massive coverup of the tunnels' existence. Usually, no motive is ascribed to the government for why it would do this, although we once saw a blog posting in which the anonymous author claimed that many Chinese residents were killed in the tunnels during the great 1900 Whiskey Row fire and that the city still fears lawsuits for reparations. Considering that the fire was nearly 120 years ago, this assertion is fairly ludicrous.

The legend of the Chinese tunnels fails to ask or answer one very important and logical question: how could Prescott's indigenous Chinese residents possibly construct a large, labyrinthine, structurally solid series of tunnels underneath Prescott without anyone noticing or attracting considerable attention? On its surface, the story is somewhat racist as well, as it contends that the Chinese were sneaky and devious enough (two traits often ascribed to the Chinese by whites in bygone eras) to pull off this huge

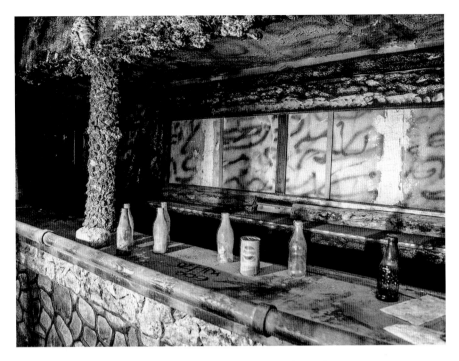

Underground speakeasy from the 1920s. *Courtesy of Isabelle Barnes-Berutto.*

feat. The suggestion that they were maybe going to use the tunnels to attack whites also feeds racial stereotypes.

In downtown Prescott, there are several buildings and old businesses that have basements, and some are very deep basements, usually used for storage by the business owners. But basements are not tunnels, and there is no sign that any of these basements were ever connected to form a tunnel.

Probably the most interesting basement is located underneath the currently condemned building that once housed Moore's Laundry at 228½ South Montezuma Street. Accessible only by a trapdoor in the floor, it contains the ruins of an old Prohibition-era speakeasy, used for illegal drinking and gambling in the 1920s and 1930s. The old bar still stands, and judging by the ruins, it was once a rather elaborate place for an illegal vice den, although as with other places in America, the Prescott police reportedly often looked the other way regarding Prohibition violations.

My Story of the Tunnels

Coauthor Wilson has talked to and worked for people who grew up in Prescott and as children played in the tunnels. Her insurance agent said that as a kid, he and several of his friends would open the metal sidewalk transit on Cortez and ride the lift down to the basement. There they would run up and down the tunnels trying to scare one another.

Another person who works for the City of Prescott said that his mother had a small café on Gurley Street next to an alley. He and his brother would sneak down the alley, enter a side door of an old building and go down to the tunnels. They would walk as far as they could in the dark before getting scared and running out.

Wilson personally knows of a business in the downtown area that has tunnels under its floor. The "tunnel" was under the sidewalk, and a brick wall separated the tunnel from the building's basement. That wall is mostly torn down now, but you can see where it was located. There are doors up to keep people out for safety reasons. They are dirt tunnels and bricked off at the far end of the property. Two other downtown businesses confirmed that

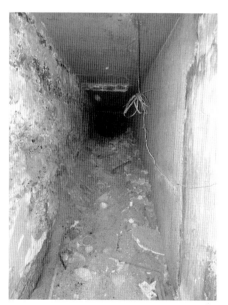

Left: Underground tunnel, possibly. *Courtesy of Darlene Wilson.*

Right: Lift to underground tunnels. *Courtesy of Darlene Wilson.*

they have tunnels and use them for storage. They said you can see the brick wall that was put up where a door was.

A restaurateur downtown said his "basement" is small, dark and all dirt and was home to Chinese residents and animals. You can definitely see that someone used to sleep down there, as well as keep animals. It may have never been a "tunnel," per se, but you can't deny that people and animals slept there at one time.

So, there is a lot of controversy about the "tunnels," which makes it all the more intriguing, wouldn't you say? People call them "cellars," "basements" and "tunnels." What is the truth? It's like many of the stories of ghosts in history—what do *you* want to believe?

Saloons, Restaurants and Shops

The Palace Saloon

For decades, the best-known and oldest business on Whiskey Row has been the Palace located at 120 South Montezuma Street. It has always been a saloon, and today it is a saloon and restaurant. It has been a staple of downtown Prescott business for generations.

The current slogan for the Palace is "Serving Arizona's toughest customers since 1877." But according to Whiskey Row historian Brad Courtney, the establishment we know as the Palace was actually opened on June 23, 1883, by proprietors Nathan Ellis and Al Whitney. Some earlier newspaper references to "The Palace" denote an entirely unrelated business. Under the management of Ellis and Whitney, the Palace was originally located on Goodwin Street, possibly one block from where it is today.

The original Palace was reportedly quite an opulent structure, and the proprietors hoped to draw a better class of drinkers and partyers than neighboring saloons did. Folklore contends that the Earp brothers and Doc Holliday spent many happy hours in the Palace, drinking and gambling, before they left Prescott for Tombstone and infamy.

But the Palace and numerous surrounding structures burned to the ground on February 14, 1884, during the huge Sherman Block fire. Ellis and Whitney decided to rebuild, as well as move the location to the middle of Whiskey Row on Montezuma Street, the site where it stands today. On July 4, 1884, the Palace held a grand reopening.

Left: Swinging doors to the Palace Saloon. *Courtesy of Darlene Wilson.*

Below: Bullet holes in the ceiling of the Palace Saloon. *Courtesy of Darlene Wilson.*

The Palace is fraught with folklore about various shootings and gunfights that took place there over the years, but these mostly have no corroboration. Bullet holes can be seen in the ceiling all around the dining room area—happy cowboys celebrating their big gold find, probably. An actual murder took place in the Palace scarcely two months after it reopened. A gambler and opium addict named Fred Glover killed his lover in the saloon, a local prostitute named Jennie Clark, aka Nellie Coyle, by beating her senseless and then throwing her to the floor and stomping her to death, while a saloon full of customers, the proprietors and even a candidate for sheriff did nothing to try to stop it.

As difficult as it is to believe today, crimes against women were often tolerated in the male-dominated society. Other men generally held the view that if a man did something horrible like this to a woman, she must have really had it coming, especially if the victim was of low repute, as Clark was. Prostitution was legal then, but the women who practiced it were viewed as parasites (of course, men who patronized them usually received no criticism). Fred Glover was tried for murder and sentenced to death, but his sentence was commuted in short order. Then, in 1890, Arizona governor Nathan Oakes Murphy granted him a full pardon, and he was freed, only six years after stomping poor Jennie to death.

The Palace changed hands several times in the ensuing years, and by 1900, it was owned by Robert Brow. On July 14, 1900, it burned to the ground along with the rest of Whiskey Row and other surrounding blocks when a great fire swept through downtown. This fire remains one of the significant events in Prescott history. The citizens pulled together to rebuild the downtown, and Brow rebuilt the Palace, the structure that still stands today.

In recent times, the Palace has had scenes for movies shot inside it, most notably the 1972 Steve McQueen film *Junior Bonner*, directed by Sam Peckinpah. Less known, the 1979 film *Wanda Nevada*, starring Peter Fonda and Brooke Shields, had scenes shot in the Palace, including a scene with veteran character actor Paul Fix.

The Palace has long had a reputation as one of downtown Prescott's haunted hot spots. But just who the spirits are is open to conjecture. Could one of them be the unfortunate Jennie Clark/Nellie Coyle? There are so many stories of hauntings at the Palace Saloon, and something is happening all the time. Of course, the common stories are of glasses jumping off the shelf, landing on the floor and not breaking. That happens quite a bit to the person closing late at night. There were brass planters that sat on the top

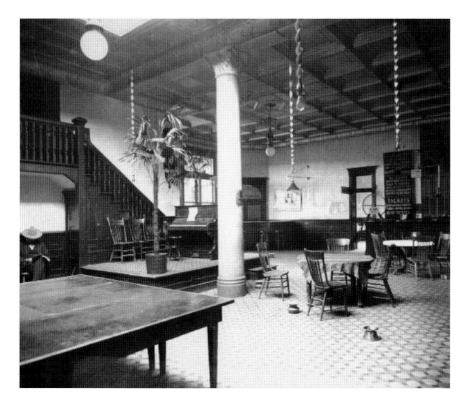

Historical 1901 Palace Saloon. *Courtesy of Isabelle Barnes-Berutta.*

shelf behind the bar, and when the owner walked behind the bar, a planter would fall, almost hitting the owner. He had the brass planters removed.

The owner had a beautiful porcelain mannequin dressed in period clothing at the top of the stairs. Located upstairs are the offices of the owner and partner now, but this used to be where two "ladies of the night" had their rooms. One day, the owner came into work and found the porcelain mannequin shattered on the floor below the stairs, having fallen over the railing. So he went out and bought "Annie," the mannequin seen now at the top of the stairs. Time passes, and the owner came to work to find that Annie had been turned completely around; he thought people were playing a joke on him, so he installed cameras. Time went by, and he came to work and noticed that Annie had been moved again, but this time her head was turned, as if watching the patrons below. The owner went through his surveillance video and saw Annie moving and her head turning, but no one is there moving her—at least no one he can see.

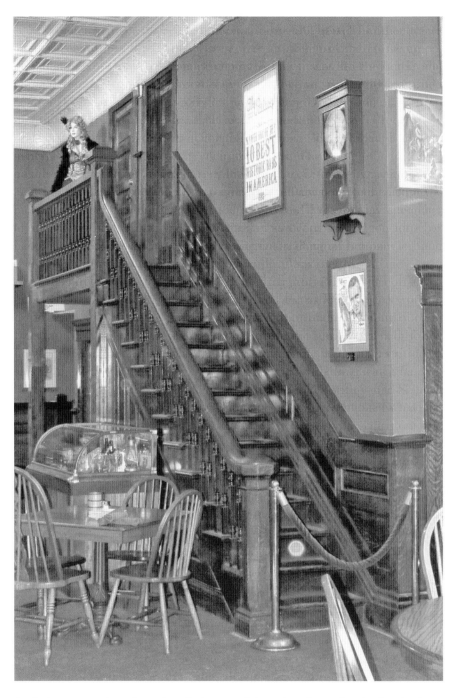

Annie the mannequin and an orb at the bottom of the stairs, where a female ghost has been seen by several employees and customers. *Courtesy of Darlene Wilson.*

There have been numerous reports of chairs and bottles flying across the rooms via unseen forces, as well as the sound of glass breaking everywhere. The employees chalk it up to a prankster ghost re-creating the bar scenes from the movie. Some have witnessed the ghost of Frank Nevin, who owned a mortuary and lost it to Sheriff George C. Ruffner in a poker game. Many feel that he is there to repeat that poker game, hoping for a different outcome. The ghost of a woman has been seen numerous times standing at the bottom of the stairs. Coauthor Wilson took pictures in the Palace one afternoon and got the most amazing orb. It looks three dimensional and the most beautiful turquoise color.

Wilson went upstairs and took pictures all around the Palace. One image was of a family enjoying their lunch, and one member had a huge orb over his head and a smaller orb on the back of his shirt. In that same area is an old buffet cabinet full of condiments. One day, a group of teachers came in for lunch and sat at the round table under the *Junior Bonner* poster. The server took their order and came out later to tell the ladies that their food was ready.

An orb in the center of the Palace dining room. *Courtesy of Darlene Wilson.*

He went back into the kitchen to get the food but suddenly heard screaming. He ran out, and his group of teachers was up and running toward the front of the saloon. He asked them what was wrong, and they said the condiments in the buffet came flying out, hitting them. He checked the table, and there were condiments scattered all over the table. He apologized, boxed up their food, charged them nothing and apologized again for the incident. One of the teachers wrote the owner a letter saying it was the best food they ever had but that they would not be returning to the Palace. The owner asked the server, "What the hell happened?" The server replied, "It wasn't me boss."

The women's restroom is haunted—oh yes, many ghostly things have happened in there. Many customers have seen orbs flying straight at them, seen stall doors banging and heard someone trying to open the door when a person is inside but no one is found outside the stall or in the whole bathroom.

One night, a group of ladies on one of Wilson's tours wanted to go into the restroom, but not by themselves, so she went with them. They were all getting pictures and videos of orbs flying. One lady said that a young lady wanted to use the restroom. All the ladies were leaving the restroom talking about the orbs and ghosts in there, and now the young lady, about seventeen years old, was afraid to go in there. Wilson introduced herself and asked if she would like her to go with her. The young woman said, "Yes please," and she led her to the restroom. Wilson asked if she would like her to wait outside in the hall, and she said, "*No.*" So, we get inside, and she went to one of the stalls, shut the door and locked it. Then all the lights went out. It was pitch black in the restroom. She came flying out of the stall, and by the time she got to the door, the lights had come back on. Wilson just said that it wasn't her, as there are no light switches in the room. All the controls for the lights for the Palace Saloon are located in one area, up front in a locked cabinet.

The basement of the building is off limits to the public because of the dangerous areas and low pipes, although it is otherwise empty. In one area in the basement, there was an opium den; there is also a staircase that goes nowhere. One area was a speakeasy and another area a home to a few temporary jail cells while new cells were being built at the courthouse. The energy in that area is very heavy and makes it hard to breathe. There is a story that one man hanged himself in one of the side rooms.

A recent incident happened to a young lady working at the Palace. She had previously worked in the basement in one of the smaller rooms, taking care of merchandising, when her job changed to a position upstairs. With her new job, she no longer had any reason to be in the basement. After several months of working upstairs, she needed to get some merchandise from the

HISTORICAL MARKER: THE PALACE SALOON

The exact age of Prescott's Palace Saloon is something of a puzzle. The first reliable documentation is an item from the September 21, 1877 Arizona Weekly Miner: "Mess'rs Shaw and Standefer have fitted up the Palace Saloon in the most superb style and fitted it with choice liquors of every conceivable kind."

An 1883 fire destroyed most of "The Row," including the Palace. Owner Robert Brow rebuilt in brick, with a stone foundation and iron roof. The interior featured a 20-foot long bar and beautiful back-bar, which had been shipped by boat and freight wagon to Prescott, three gaming tables and two club rooms.

On July 14, 1900, much of downtown Prescott burned to the ground, including the "fireproof" Palace Saloon. Patrons managed to salvage much of the liquor and the bar, all taken across the street to the Plaza, where drinks were served as the fire progressed. After the fire, Robert Brow and the owners of the Cabinet Saloon pooled their interests and determined to build "the finest and best club house, saloon, café, etc. that Arizona has ever had, or in fact that can be found west of the Mississippi River."

The new Palace Hotel, designed in the Neo-Classical Revival style, took over the front page of the June 29, 1901 Prescott Journal Miner. It was the most elegant pleasure resort along "The Row." The Miner described the interior furnishings as "rich and elegant" with only the best materials used. The bar and fixtures were described as "the crowning features of the furnishings" and "without doubt the most elegant in this part of the country." Three large gaming tables encouraged faro, poker, roulette, kino and craps. A glass of beer was five cents, and a man could pay for his drinks with unminted gold.

In 1907 a State law outlawed wagering and games of change, along with their "attendant evils" and Prohibition during World War I closed many a saloon, but the Palace held on. In 1996 The Palace was closed and in severely deteriorated condition when restoration began. Working from old photographs, the elegance of the Palace Hotel and Saloon of 1901 was recaptured. The Palace is listed in the National Register of Historic Places.

Funded by the City of Prescott

basement. She grabbed what she needed and wasn't down there but a few minutes. She was walking out toward the alley when she felt pain on her chest and stomach. She looked down and saw multiple scratch marks on her body. A partner of the Palace contacted Wilson and asked if she would call her, talk to her and maybe meet with her. She did, and we decided to meet several days later at the Palace and walk through her experience. When Wilson saw her, the scratch marks had healed, but she showed her pictures that her mother had taken; there were indeed numerous scratch marks on her body. They talked for a while and then went downstairs, where she took her through that day. Although they got several changes in temperatures and snapped a few pictures of metallic orbs, nothing happened to the young woman. They were walking toward the alley and chatting when, all of a sudden, Wilson noticed a scratch beginning to show on the young woman's chest. Wilson believes that the spirit located in the basement missed the young woman and wanted her back working in the basement. He was trying to grab her to keep her from leaving.

There has never been any pain or attacks produced by spirits before, and coauthor Wilson doesn't think they would start now. She truly believes that it's someone wanting the young woman's attention and wanting her to stay down there. What do you think?

Matt's Longhorn Saloon

The building at 112 South Montezuma began its life, different stories say, in 1870 or 1903 as a mercantile called D. Levy & Company General Merchandise. We know that the fire destroyed the building in July 1900 and that it was rebuilt in 1901 and housed the mercantile store until 1934. With the ending of Prohibition, the store was replaced by Matt's Longhorn Saloon, known as Matt's Saloon.

Matt's Saloon is not a dive bar; it is a dance hall featuring great country music. The swinging wooden doors have been there on Whiskey Row since 1962. The skulls and mounted game decorate the walls, and the twenty-foot bar invites guests to hang out, have a few drinks and maybe take a turn on the large wooden dance floor.

Matt's has had its share of celebrities and politicians stop by for a beer or two—some before they became famous, like Waylon Jennings and his band, the Waylors. They performed there in July 1965. That night, his band was

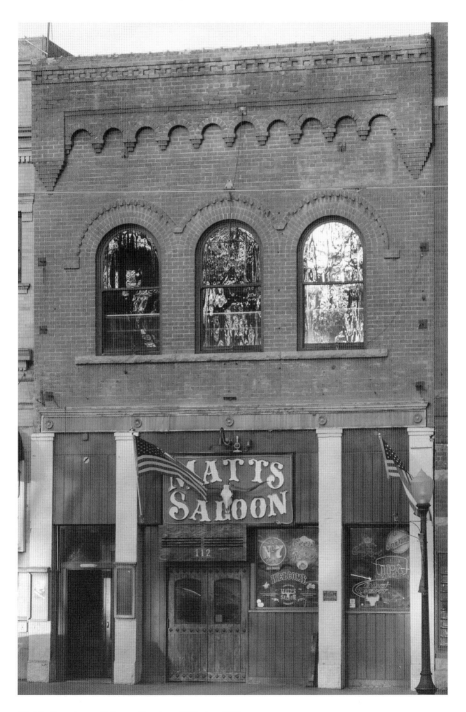

Matt's Longhorn Saloon. *Courtesy of Darlene Wilson.*

short a drummer, so Matt's house drummer, Richard Albright, played with the Waylors and became a band member. The band tore the roof off the place. Jennings came back to perform at Matt's several more times in his early years of fame.

In October 1989, those swinging doors at Matt's Saloon opened to "the Boss," the one and only Bruce Springsteen, who was traveling through Prescott but decided to stop for a beer. He borrowed a guitar from a member of the house band, and soon the place was rockin'. When Springsteen took a break, the bartender, "Bubbles," pulled him over to the bar for safety. The word got out that "the Boss" was in town, and *everyone* showed up at Matt's. Bubbles and Bruce got to talking, and she shared stories of her ill health and sky-rocketing medical bills. Bruce was so grateful to Bubbles for rescuing him from the packed saloon that he paid off her $160,000 hospital bill.

Several Music Hall of Famers like Waylon Jennings, Buck Owens and singer/songwriter Lee Hazelwood played at Matt's during the '60s. Other country performers or bands that either played or drank there included Joe Diffie, Asleep at the Wheel and Andy Griegs; Vince Gill stopped in after playing a concert in Prescott Valley. Steve McQueen frequented Matt's while filming *Junior Bonner* in Prescott in the summer of 1971. Actor Ben Johnson and director Sam Peckinpah were among the other Hollywood notables who visited Matt's.

Is Matt's Saloon haunted? Oh, most definitely! One ghost at the saloon has been seen by employees as well as customers. It's the ghost of a little girl that shows up in the ladies' restroom asking for someone to help her find her mommy. They mistake the ghost for a real little girl, and before they can get help for her, she disappears. The owners, employees and customers have seen the ghost of a cowboy. A tall man, wearing a long black duster and cowboy hat, makes his way to the bar as if going to order one more drink.

Paranormal investigators have produced electronic voice phenomena (EVPs)—sounds found on electronic recordings that are interpreted as spirit voices—of both a male cowboy voice and a female voice having a discussion. Another recording features a voice that says, "I'm such a loser. I'm such a loser," and another voice that agrees, "You're such a loser."

The door locks in the ladies' restroom move, sometimes violently. Then the men's restroom starts seeing the same thing. A security guard late one night felt someone tug on his pant leg while he was working the front door. When he turned around, no one was there.

RICKETY CRICKET BREWING COMPANY/FAR FROM FOLSOM/COYOTE JOE'S/ANNIE'S ATTIC/CANTINA/COUNTY SEAT RESTAURANT/ARIZONA HOTEL

As you can tell by all the names (and this is not even all of them), this building at 214 South Montezuma Street has been around a very long time, since the late 1800s. Far from Folsom closed its doors in May 2018, and the new business is Rickety Cricket Brewing Company, part of the original Whiskey Row. People believe that Whiskey Row is just one block between Gurley Street and Goodwin Street, but this is not true. Whiskey Row started at Sheldon Street at the former train depot and ran south to the present-day Mile High Middle School.

At the beginning, it was the Arizona Hotel, a brothel that was built in the notorious red-light district. The Arizona Hotel comprised two stories and a basement. Although reports say the basement had so-called tunnels and was home to opium dens, this has not been proven to be true.

Far from Folsom, upstairs. *Courtesy of Darlene Wilson.*

Far from Folsom, swinging doors. *Courtesy of Darlene Wilson.*

The main floor is where the kitchen is located, as well as a restaurant area separate from the bar. It is very evident that the former establishment, which is now the kitchen, was once the main room for the brothel, which had many doors leading to the prostitutes' rooms. This was all noticed in

Far from Folsom, steps to the upstairs.
Courtesy of Darlene Wilson.

1997, when Coyote Joe's moved into the building. It was quite apparent what the former establishment used to be. The second floor had obvious outlines of the many small rooms used by the "ladies of the night." Fire damage was apparent from a fire started by a very unhappy customer.

The previous owners established Annie's Attic, a nightclub located upstairs above Coyote Joe's, where customers could enjoy drinks and a game of billiards or just relax in a much calmer environment than at Coyote Joe's downstairs. It was named after the ghost of a young girl that talked to the owner's cousin. She told the cousin that there would be a fire in Joe's, and two weeks later, there was a fire in the dining room.

Many customers and employees say that they get a sensation that they are not alone, that someone is there watching them. They also believe that some of the ghosts are possibly prostitutes who worked there, as well as miners and cowboys who visited the brothel.

The kitchen seems to be a great place for the spirits to gather and hang out. They turn the oven and burners off before the food is ready. One of the new bartenders was closing early one morning when the pans and utensils started flying across the room. He took off running, called the manager and said, "I'm out of here, and by the way, someone needs to go close the front door and lock up."

Some of the employees believe that the first floor is more haunted than the top floor because of the voices and footsteps they hear all the time. One spirit is a kind old woman that causes candy to drop from a candy machine. The ghost of a young woman has also been seen standing in the foyer.

The owner of Rickety Cricket, Terry Thomson, said that during the renovations of the new restaurant many strange things happened to him and his staff. One night he was in the kitchen working when one of the spice containers went flying across the room. On another night, he and another employee were the only ones there. There were three raps on the wall, and

Terry thought it was the employee trying to scare him. Terry was telling his employee to stop when he saw him outside, waiting for Terry. Then Terry heard the three raps again, only louder. Another employee is very familiar with the building; as a child, he used to play with Annie, not knowing that she was a ghost. Terry and his staff all believe some of the ghostly activity comes from Annie.

Although the ghosts/spirits aren't scary, they may be there because they like the place, with all the activity and the music.

GURLEY STREET GRILL/MULVENON BUILDING

Located at 230 West Gurley Street, so named for the many establishments that once housed "ladies of the evening," today's Gurley Street Grill serves some of the finest food and beverages in a friendly, relaxed and informal atmosphere. The historic structure was constructed of local brick, some of it salvaged from the rubble of the Great Fire of 1900, which destroyed the Mulvenon Saloon, a wood-frame building originally located on the site. The Gurley Street Bar soon rose from the ashes of the Mulvenon, and one can still see soot-blackened brick scattered throughout the structure. At the turn of the century, the upstairs rooms were comfortably furnished and rented by the hour or by the day. They now serve as private banquet rooms to accommodate large parties. The business's website does, in an abbreviated form, share a little of the history of this amazing building. Of course, stories passed down through the years, maybe over one hundred years, may have changed a little, but the stories and history are wonderful nonetheless.

The Mulvenon Building, named after the owner, William J. Mulvenon, has gone through many changes, whether structural or ownership-wise. Mulvenon moved to Prescott in 1876 and was elected sheriff in 1885. He later served as a territorial legislator and had the Mulvenon Building built in 1901 after the Great Fire. It was one of the first buildings built after the fire. Because the disaster burned most of downtown Prescott, Mulvenon decided that wood was not the way to build future buildings, so he made the change to brick.

The first floor was a saloon that Mulvenon operated himself. During Prohibition, the saloon served "sodas." There was some talk that "ladies of the night" worked in the furnished room upstairs. Although not proven

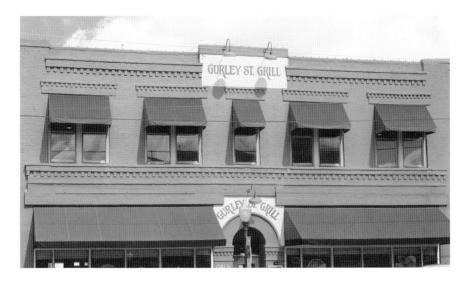

Gurley Street Grill. *Courtesy of Darlene Wilson.*

to be true, there is evidence in the structure. Also the building was located across the street from the more formally designated houses of prostitution. Being outside the red-light district, it would have been illegal to have any operation in the saloon. It was documented that prostitutes did work outside the district, so it is a possibility.

Gurley Street Grill has been at this location for more than twenty-one years and has been a very important part of Prescott city life, as well as haunted life. George is a friendly ghost that lives upstairs. He has been known to make the lights flicker on and off, mess with the computer system and rearrange coffee cups. No one knows for sure who he really is. Was he a customer who hung out at the saloon and maybe rented a room upstairs or visited one of the ladies of the night? For whatever reason, he must like it here because of all the activity and good company who frequent Gurley Street Grill. Those folks working there after closing hear footsteps coming from upstairs. The noise sounds like ladies' heels walking around, pacing back and forth.

HISTORICAL MARKER: MULVENON BUILDING

Completed in August 1901, the Mulvenon Building was one of the first buildings constructed after the fire of 1900. It replaced a one-story wood-frame saloon building which was destoyed in the fire. Built by William J. Mulvenon, who arrived in Prescott in 1876, it is typical of the late nineteenth-century Territorial Commercial style with a prominent central arch over the main entrance. It is constructed of locally made brick, although the brick on the front of the building is of better quality than the brick in the rest of the building. Originally there were two retail bays on the ground floor and hotel rooms on the second floor. The west half of the building at one time housed "Prescott Vulcanizing Works" and the east half was a saloon. Rooms were available for rent until 1991. In 1991 the building was restored and converted into a bar and restaurant.

W.J. Mulvenon originally worked as a stable keeper at Peck's mine. He later served as deputy sheriff and as sheriff of Yavapai County, leading two posses into Tonto Basin to restore law and order during the Pleasant Valley War. He was instrumental in establishing the Crystal Ice Company, the first ice plant in Prescott and was organizer of the Arizona Brewing Company. The Mulvenon Building is listed in the National Register of Historic Places.

DEVIL'S PANTRY/ADIRONDACK CAFÉ

For more than one hundred years, this location (126 South Montezuma Street) has always housed a restaurant of some kind. Several years ago, I knew it as the Adirondack Café. The owner/chef did not believe in ghosts, but he showed me his basement. It was small, had a low ceiling and was old and all dirt. On one side, you could see where people had slept down there, and on the other side, you could tell that at one time, long ago, animals had been kept there as well.

The food was outstanding, and I would go there often for meals. One night, the owner came over to my table and said that he had a ghost. Of course, I was shocked that he would even say that since he didn't believe

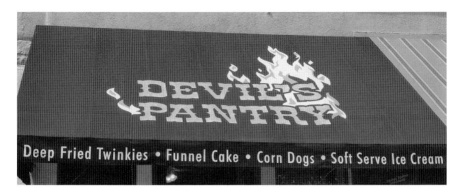

Devil's Pantry. *Courtesy of Darlene Wilson.*

in ghosts. He proceeded to tell me what had happened. One night, the last patrons there were a couple who were just finishing their dinner. They asked him what was upstairs—an apartment? He said no, that it was his office. They asked if a woman with red hair worked at the restaurant. The chef said no—just the server and himself that evening. They said that they saw a red-haired lady come down the stairs, and the chef said he didn't have a clue what they were talking about. The owner/chef checked upstairs and his staff checked downstairs and in the back for the lady, but they never found anything.

Several weeks later, the chef had a customer stop in for dinner who said that when she was a little girl, her family would come to Prescott to visit her grandparents. Her grandparents would always bring the family into the restaurant that was there at that time. Then, one day, she realized that they had stopped taking her to the restaurant. When she was older, she asked them why they had stopped going to that restaurant, and they told her there had been a murder. An Irish woman has been shot at that very restaurant. Now she haunts the restaurant. I wonder what she's searching for. Does she know that she is dead?

Marino's Mob Burgers

Across the street from the east side of the courthouse, at 113 South Cortez Street, about one block away from Whiskey Row, there is a popular restaurant called Marino's Mob Burgers. This location has been a restaurant of some kind for a great many years. Long-time Residents of

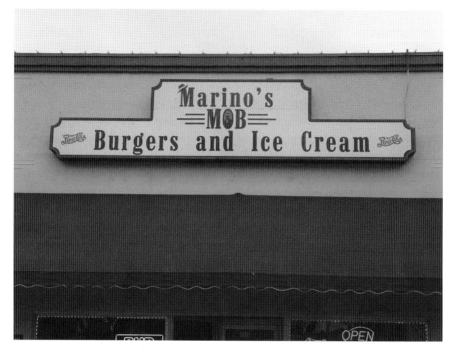

Marino's Mob Burgers. *Courtesy of Darlene Wilson.*

Prescott, a private group of citizens, recalls that a key scene in the 1971 hit counterculture movie *Billy Jack* was filmed here, when it was known as Dent's Ice Cream Parlor.

For many years, this establishment was known as Kendall's Famous Burgers. We talked with a former employee of a local alarm company who told us that he used to get complaints from the owner during this period. There were a number of instances when the owner came to work in the mornings, only to find various food items and equipment violently strewn all over the floor—yet the security alarm had not gone off to report the intruders. Tests showed that the alarm was working properly, so after the third or fourth time this happened, the alarm company employee came to believe that Kendall's was the ongoing victim of a poltergeist. One construction worker said there was a tunnel located in the basement. It was bricked up, so he had no idea why it was there.

Arts Prescott Gallery

The Arts Prescott Gallery at 134 South Montezuma Street on Whiskey Row is a local art gallery of recent vintage, but for many years, there were a number of restaurants in this location. Longtime Prescott residents recall the Green Frog Café being here. In 1920, it was the American Kitchen Café, and on November 1, 1920, a fifteen-year-old waitress named Annie (or Anna) Beck was shot to death with a pistol shortly after reporting for work. A coroner's inquest was quickly empaneled.

Coroner's inquests are seldom, if ever, held anymore, but they were common in those days as a tool of law enforcement. If someone died under questionable circumstances, the county coroner would quickly round up a group of local citizens, and this impromptu coroner's jury would hear testimony from witnesses and rule a cause of death from that. If they ruled that it was anything but murder, the case would be closed without a police investigation or an autopsy.

This is how it was for poor Annie Beck. The coroner's jury heard testimony from her acquaintances, who stated that she suffered from bouts of despondency and had threatened to kill herself in the past. Also, the first witness to find the victim testified that he did not see how anyone but Annie Beck herself could have pulled the trigger.

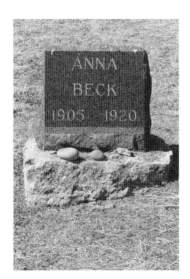

Anna Beck's headstone. *Courtesy of Darlene Wilson.*

With this kind of testimony, the coroner's inquest ruled Annie's death to be a suicide, and no further investigation was done. She was quickly buried in a remote grave at Mountain View Cemetery. Could she be one of the restless spirits that haunt Whiskey Row?

Annie Beck's family never believed that she really committed suicide, and down to the present day, the family's descendants believe she was the victim of an unsolved murder and then further victimized by the old coroner's inquest system that almost always prevented a police investigation. In 2007, Blue Rose Historical Theater, founded by Jody Drake and then located at Sharlot Hall Museum, staged a reenactment of the coroner's inquest and poked holes in

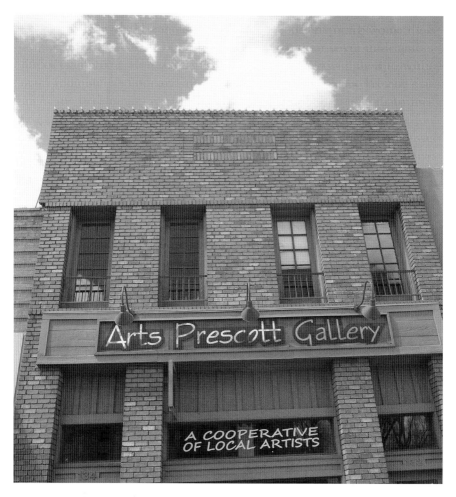

Arts Prescott Gallery. *Courtesy of Darlene Wilson.*

it with a script by Randi Wise, a descendant of the family. At the end of the reenactment, the audience was asked to come to a verdict. Every night, the audience returned a decision of "foul play," even though those present heard virtually the same testimony the real jury had heard in 1920.

HOTELS AND B&BS

HOTEL VENDOME

The quaint, rustic Hotel Vendome is located at 230 South Cortez Street, roughly half a block south of the Courthouse Plaza. In operation since 1917, the Vendome has developed a reputation (through both folklore and experiences of guests) as one of the most haunted sites in Prescott. When asked about paranormal activity in town, the name of the Hotel Vendome immediately comes to mind for most people.

According to the hotel's historian, Ken Edwards, the Vendome was built in 1917 by John Benton "Jack" Jones, a Texas-born ex-rancher who had moved to Prescott and had started purchasing property. He built the Vendome purely as a business/real estate venture during a period when the hotel business was booming in Prescott. It was located next door to Jones's home on Cortez Street.

There are many persistent legends about the hotel, including one that Jones built the Vendome as a gift to his new wife, who promptly left him after finding out. But surviving Yavapai County marriage records show that Jack Jones was married in June 1919, two years after the hotel was completed, to a sixteen-year-old girl named Marguerite, who was, needless to say, far younger than he.

It is unknown where Jones came up with the name Vendome for his new hotel. But an article in *Yavapai* magazine in November 1917 wrote about

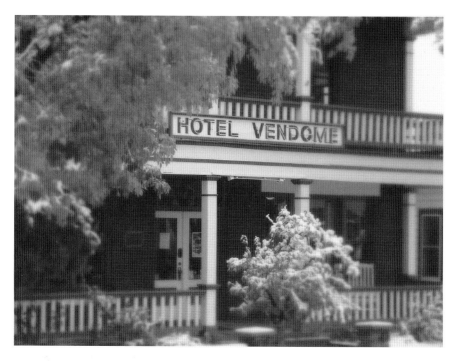

Hotel Vendome. *Courtesy of Darlene Wilson.*

it this way: "For the past two years Prescott has been suffering for want of houses....To meet this urgent demand for a place to live, the attractive Hotel Vendome on south Cortez has been opened early in November. The structure is strictly modern. It is built of red pressed brick and its comfortable home-like appearance must solve the problems of many who are interested in house hunting."

Jones hired Clara Worthen to manage the hotel. Worthen was newly divorced from her husband, Charles, and would manage the Vendome for about six months, after which she moved to become proprietor of the Head Hotel on North Cortez Street, where she stayed for many years.

After that, Jones hired Josephine Brow, widow of the former owner of the Palace Bar, to manage the hotel. In 1924, though, Jones sold the Hotel Vendome to Henry Brinkmeyer, a local businessman who owned the Brinkmeyer Hotel on Montezuma Street. According to historian Ken Edwards, Jones pretty much traded the hotel to Brinkmeyer in exchange for some ranchland that he would develop and name the Spider Ranch.

Quite a few owners and managers have come and gone since then, and today, the Hotel Vendome remains a popular stopping point for tourists. It

has also become arguably the best-known haunted site in all of Prescott, with much of the focus being on room 16 (which you can specifically request if you stay here; rumors that the management has closed off this room due to the ghosts are not true).

The legend of whose ghost haunts the Vendome goes something like this. A lady named Abigail (or Abby) Byr and her husband owned the hotel in its early years and lost it due to tax difficulties. The new owners let the Byrs stay on in room 16, but one dark night circa 1922, Mr. Byr (who never has a first name when this story is told) went out on an errand and never returned. (The story is that Abby was sick and weak from TB, and her husband goes out to get her medicine and never returns.) Distraught, Abby locked her cat, Noble, in her closet and herself in room 16, and they both starved to death. It is supposedly the spirits of Abby and Noble that haunt the Hotel Vendome.

This story has been told so widely that few have questioned it, but serious historians have spent many years trying to corroborate this tale and have come up empty. The trail of property records for the hotel contains no gaps since it was built—no one named Byr ever owned the Hotel Vendome. There is no record of Abby or anyone else named Byr in local census or death records. In short, there is no documentation that Abby Byr ever lived, or died, in Prescott, let alone at the Hotel Vendome. There is no record of any kind that she ever existed at all.

The story has logistical problems as well. It would have taken a long time for Abby to starve to death, yet in a working hotel, no one ever checked on her or the room? Furthermore, a starving cat would be yowling its head off, which surely would have attracted considerable attention if it had really happened this way. Coauthor Wilson heard the story that Abby was very ill and very weak, and she locked her cat in her closet and shut herself in her room; they both starved to death. In 1921, when it is believed she died, it was more of a boardinghouse instead of a hotel. At that time, it is not known how busy the hotel was or how many guests were in the hotel, if any.

Unsettling paranormal phenomena and ghostly encounters are generally believed to have started around the time of the Vendome's extensive remodeling in 1983. Perhaps the ruckus disturbed a long-dormant spirit or spirits. But is it Abby? The hotel's owner at the time later told historian Ken Edwards that she believed the name Abby Byr started one night with a group of college students that was partying in a room with alcohol and a Ouija board—then folklore took over from there. But in more recent years, various paranormal investigators ("ghost hunters") have descended on the

Room 16, Abby and Noble's room. *Courtesy of Darlene Wilson.*

Hotel Vendome and come away swearing that they believe the story of Abby and Noble to be true.

Coauthor Wilson had the privilege of working at the hotel, helping out the previous managers of the Hotel Vendome, and had many experiences that cannot be explained. She knows that there is a female ghost and a cat ghost that reside in room 16. She knows from experience and has pictures of the ghost cat chasing a ghost mouse. She also has heard the many stories of guests who stay in room 16, including the following.

A guest staying in that room for a week wanted something to happen so badly. On her last night, with a disappointed face, she said she was leaving tomorrow and was so sad that nothing had happened. Wilson said she'd give her a saucer of milk she could put in her room to see if something happened. The next morning, she came rushing downstairs saying that at 2:30 a.m., she woke up to a cat kneading her shoulder. Wilson was so happy for her and said, "We aim to please."

Another guest and her two nieces were spending the night in room 16. She said she always takes her nieces to haunted places on their spring break

and always has a recorder with her. That evening, she turned the recorder on and stated the date, time and location. When she played it back, she heard very clear and loud cat meows. It sounded like Noble was standing on top of the recorder.

There is one couple who stay at the Vendome three times a year and always in room 16. They go to bed around 10:00 p.m. and set their alarm for 2:00 a.m., when they get up, set up their equipment and start recording and filming in Abby's room. The next morning, the guest across the hall in room 17 checked out. The front desk clerk asked how her stay was and whether she slept well. The guest responded that in the wee hours of the morning, she heard a woman's voice saying, "They just won't leave, they just won't leave." Wilson believes it might have been Abby, frustrated with the couple staying in room 16 trying to film and record her.

Recently, a couple was staying in room 16 when the woman woke up in the middle of the night. There, standing at the foot of the bed, was a ghost. She said that he was a black man with short gray curly hair and a short gray curly beard, wearing a white long-sleeve shirt, a black vest and black pants. She felt like he was in charge of other servants. He nodded to her and said, "Just passing through" and disappeared.

The closet hangers have been heard moving by themselves. There was also a "creepy" dress hanging in the closet; when guests would go to hang up their clothes, the dress would be turning around and around by itself. Or when they opened the closet, the dress would be hanging on the right side of the pole; when they would bring their clothes to hang them up, the dress would be on the left side of the pole. It was not Abby's dress, but the style of the dress was from the 1900 era.

Guests often talk about feeling a cat jump on their bed. There are cat toys under the bed, and guests wake up to hearing them being batted around or hearing the sound of a cat scratching on the closet door and meowing.

One young girl turning sixteen years old wanted to stay in room 16 with a girlfriend. Because of her age, a parent had to be with them. Her mother said that by the time they had checked in, the girls had totally freaked themselves out. The mother got them in room 16 and kept telling the girls that it was just a story, that everything was fine and safe. The mother felt someone tap her on the shoulder, and when she turned around, no one was there. They did spend the night in the hotel, but staff had to find them another room to stay in.

Abby and Noble are not the only ghosts at the Vendome. On another night when Wilson was working late, a couple came in wanting to see a

room. She showed them room 3, and while explaining the hotel information and the excellent location to downtown, she saw a shadow walking down the hallway. It was a cowboy, about five-foot-nine and wearing a cowboy hat. She kept watching the shadow walk down the hall and continued talking to the couple. They turned around to see what she was watching, and she explained that it was nothing.

Two weeks later, the Paranormal Network TV people were visiting from Las Vegas; they had the whole hotel to themselves and were setting up equipment in Abby's room. One of the investigators went downstairs to get a drink of water and saw a shadow at the end of the hall, toward room 14 and room 15. He asked Wilson about it later, and she shared the experience she had.

Four months later, a guest staying upstairs in room 20 came down and introduced herself to the staff member Stephanie, who was working that day. The guest said she was a medium and wondered if they were getting any strange noises on the first floor. Steph said they had been hearing noises at the end of the hall that they've never heard before. The guest asked if she could go sit in the rooms at the end of the hall, and Steph consented. Thirty minutes later, the guest came out and said she believed that a cowboy had been staying in room 14 who was very attracted to the lady across the hall in room 15 but was very shy and would not say anything to her. The guest said that she believed the cowboy would go out to Whiskey Row, have a few beers, come back to the hotel, get a chair, put it outside under her window and sit there all night to make sure she was safe.

One year later, Wilson was visiting the hotel one afternoon and took a picture of two orbs in the lobby. Not long after, a friend introduced her to Cherise. Cherise is very intuitive and came by her "gift" after dying on the operating table during surgery. The first thing Cherise asked was whether Wilson's mother had just passed away; she said, "Yes, she did." Cherise said that her mother was with them now, and Wilson thought, "That's interesting because my mother did not believe in any of this stuff." Her mother lived in the Bible Belt and did not believe in ghosts or anything paranormal. Next, Cherise said, "Your mother wants me to tell you that she'll never admit you were right." Cherise went on to tell Wilson other things that only she and her mother knew.

Wilson asked Cherise if she had ever been to the Hotel Vendome, and she said that she'd never been to Prescott. Wilson then showed her the picture of the two orbs in the lobby of the Vendome. She looked at it and said, "The orb on the right is a cowboy, a security guard or watching over someone. The one

Orbs in Hotel Vendome's lobby. *Courtesy of Darlene Wilson.*

on the left was a woman." Then she said, "Oh, that's who he is watching over." So, here were similar references to a cowboy from three different sources, in addition to Wilson herself, who saw the shadow of the cowboy walking down the hall. Yet she was not the only one who had seen the shadow. Many guests have asked about the shadow at the end of the hall.

Another interesting comment made by Cherise was that the Hotel Vendome was a portal and that is why it gets so many sightings and voices when investigations are conducted at the hotel. One thing noted is that it doesn't matter what room or what time, day or night the hotel is investigated—they always get something or someone.

While working at the hotel in 2010, Wilson was working late sitting in the office at the desk when she felt a cat brush up against her leg and meow. She had a cat at home, so she didn't really think anything of it. She looked down, and of course, nothing was there. So, she said, "Ok, Noble, what do you want?"

Wilson does the haunted and historical tours in Prescott, and she meets the tour group in the lobby of the Hotel Vendome. One lady arrived early for the tour; while she was standing in the lobby waiting for the others to arrive, she felt something or someone walk by her. Then the double glass doors to the hallway opened and closed, as if someone passed through them.

There was a miner who committed suicide, and it is believed that he was in room 31. One couple on Wilson's tour told her about staying in room 31. When

the woman woke up around 3:00 a.m., she saw a man standing beside their bed. She woke her husband, and as he rolled over, he caught a glimpse of the man. The couple did continue to visit at the hotel but did not stay in room 31.

A previous manager hated going downstairs to the basement. At that time, there was a crack in the foundation, and homeless people would sneak in there to sleep at night. One day, the manager heard noises in the basement and started down the stairs to see what it was. She said that Abby appeared before her, holding up her hand as if to stop the manager from going down the stairs. The manager turned around, closed the basement door and contacted the owner. He came over, went downstairs and found several homeless people staying down there. Probably harmless, but nonetheless, it was a little unsettling. Would the manager have come to harm if she had gone down the stairs by herself? Was Abby trying to warn her of danger?

The year 1918 saw the death of one of the guests: Hertha Hills Beaton, a young woman from Germany. She died of pneumonia. Here is the newspaper article announcing her death:

Young Wife Dies at the Hotel Vendome, a Victim of Pneumonia
Weekly Journal-Miner Wednesday Morning November 20, 1918
(From Saturday's Daily)

An epidemic of influenza and pneumonia which has been preying upon Prescott for the past several weeks, claimed the life of another young victim at six o'clock yesterday evening at which time Mrs. Hertha H. Beaton, wife of James Beaton, local representative of the Goodyear Tire & Rubber Company of Akron Ohio, passed away at the family apartment in a local hotel, the Hotel Vendome. While Mrs. Beaton has been confined to her bed for nearly four weeks, her passing was most unexpected, and came a few moments after she had partaken of the evening meal. She was apparently well on the road to recovery and her physician, Dr. K.A. Loony, had announced that she had passed the danger point. However, shortly before six o'clock she suffered a relapse, and before her physician could be summoned, she passed away peacefully in her husband's arms.

Hertha Hella Rasch was born in Kiel, Germany, in 1893. She came to the United States during her girl hood and was united in marriage to Mr. Beaton at Chicago on November 25, 1915. Mr. and Mrs. Beaton left their former home at Fort Wayne, Indiana, in April, 1918, and came to Arizona, where Mr. Beaton took up his duties with the Goodyear organization. They had been residents of Prescott for the past two months, and while Mrs.

Beaton's acquaintances were naturally not numerous because of her brief stay here, she had won many friends by reason of her attractive personality and her winsome disposition, and her loss will be keenly felt. At present no funeral arrangements have been made, other than the decision of the husband to have the remains interned in the Mountain View cemetery. Because of the censorship regulations, Mrs. Beaton had not been able to communicate with her parents in Germany since the outbreak of the war, and it is probable that the latter cannot be appraised of her demise for a number of months. Eastern friends of the deceased are expected to arrive in Prescott within the next few days to be present at the obsequies.

Coauthor Wilson believes that Hertha died in room 20. There is no record of which room the Beatons were living in, but many guests who stay in that room always say the same thing. They see something out of the corner of their eye, and when they turn around, no one is there. Wilson believes that she is a quiet, shy young woman who tries to stay out of the guests' way and hovers in the corner. Are you brave enough to stay in room 20 to meet Hertha Beaton?

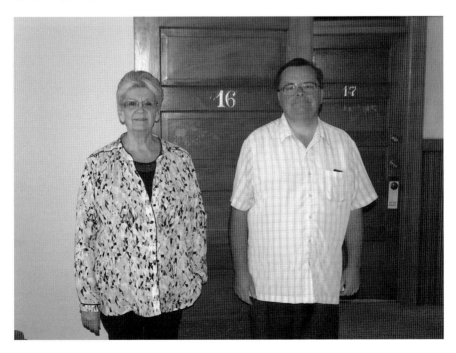

Authors Darlene Wilson and Parker Anderson in front of room 16, Abby's room. *Courtesy of Shane Phipps.*

HISTORICAL MARKER: HOTEL VENDOME

The Hotel Vendome, referred to in a contemporary newspaper article as an "apartment house," was built on South Cortez Street in 1917 by J. B. Jones. An article in Yavapai Magazine in November 1917 refers to it as the "Hotel Vendome" and states "its construction will fill a need for housing in the town which was crucial even when the summer visitors were induced to return home." The hotel is constructed of dark red wire-cut brick with a traditional brick cornice. A two-story veranda extends across the front of the building. It is the only Prescott example of a two-story structure built exclusively for residential use during the first quarter of the Twentieth Century.

The Hotel Vendome was advertised as an "attractive small hotel with 30 rooms and 16 baths, wide verandas upstairs and down, attractive lobby, hot and cold water in all rooms, night and day phone service with buzzers in all rooms, excellent steam heat, free parking, one-half block from the Plaza, one block east of Highway 89, rates are reasonable with $1.50 single and $2.50 double." One of the Hotel Vendome's more famous guests was Tom Mix, who rented a room by the year. The Hotel Vendome was restored and modernized in 1983 and is listed in the National Register of Historic Places.

A reporter with the *Daily Courier* in Prescott said that she rented room 16 for one night to check on Abby. "I believe she paid me a visit," the reporter said. She said that the *Courier* photographer was with her when she entered the room. Noticing that the room was cold, they turned on a radiator. When they returned after dinner, the room was still cold, and the radiator was off. The reporter said she turned the radiator on again. After the photographer left, having given the camera to the reporter in case something turned up, the reporter said she sat in the room thinking about the stories Patel (the owner of the Hotel Vendome) told her about Abby and the room's previous living occupants—one of whom said the heat kept going off. "I check the radiator. It was off again," the reporter said. Later, she said that she was repeatedly woken up by a cat's meowing, but each time she tried to approach the apparent source of the sound, "It seemed to move." The heat never did stay on, she added. When the roll of film in the camera was developed the

next day, "There was a faint picture at the end of the roll that neither of us had taken," the reporter said.

There are dozens and dozens of stories, and the hotel keeps a book of them in its lobby. Some of these stories are from guests and some from previous managers and staff. When staying at the Hotel Vendome, ask to see the book. It's very interesting.

HASSAYAMPA INN

Located at 122 East Gurley Street, directly across the street from the Elks Opera House, stands an impressive hotel, the Hassayampa Inn. Designed in Spanish Colonial Revival style, it has served the needs of travelers since 1927.

By the early 1920s, Prescott had formed a chamber of commerce and, in the new age of automobile travel, had started boosting itself as a tourist attraction. Even though the town had several hotels already, Prescott's civic leaders decided that a new one was needed—one that could be advertised as specifically catering to the traveling tourist. They came up with a name early on: the Hassayampa Hotel, named after the famous river in central Arizona. It didn't matter to them that the Hassayampa River did not flow through Prescott. A small corporation was formed to get the ball rolling, named (of course) the Hassayampa Hotel Company, with a board of directors that consisted of Francis S. Viele (president), Moses B. Hazeltine (vice-president), Charles C. Miller (secretary), Dr. John W. Flinn, LeRoy Anderson, James E. Whetstine, Harry W. Heap, J. Faulkner, Robert Tally and Samuel S. Perry.

The board hired local architect Chris Totten to design the new hotel. In those days, when large construction projects needed financing, backers sold stock in the forthcoming building. This was how the Elks Opera House had been built, and the Hassayampa Hotel Company board followed suit by selling and subscribing stock in the building. Large amounts of the stock were purchased by the local Kiwanis Club, as well as by the United Verde Mining Company in the town of Jerome. Both organizations had members sitting on the board.

The site chosen for the new hotel was on the vacant lot where the old Congress Hotel had burned down in 1923. There were delays getting started, but in the end, ground was broken for construction in early 1927 and work progressed. By November, the spectacular hotel, with its large,

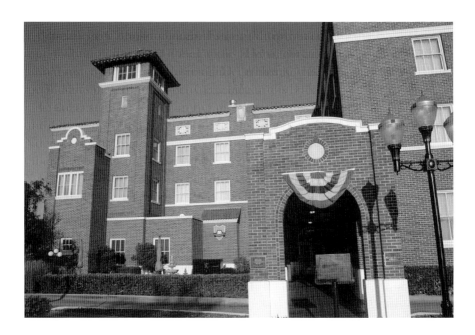

Above: Hassayampa Inn. *Courtesy of Patrick Izzo.*

Left: Hassayampa Inn sign. *Courtesy of Darlene Wilson.*

opulent lobby, had been completed. A gala celebration was held in the new building on November 5, 1927, with gourmet food, plenty of first-rate liquor and lavish decorations. The *Arizona Journal Miner* newspaper reported:

> *The Dutch treat table, over which Mr. and Mrs. Harry Heap presided, was a wonderful surprise to the guests. In the center was supported a pennant bearing on a field of blue the word "Hassayamper" in white letters. The other decorations carried out the idea of the early days of Prescott. A long ribbon of gold colored crepe paper centered the table and at intervals there were set up small logs of pine wood with the bark still clinging to them. Around these was arranged miner's candlesticks in which were placed small yellow candles. At either end, there was a miner's pan, such as was used in the early days for washing gold. In these were arranged button chrysanthemums in yellow to simulate gold nuggets. The unique idea was originated with Lester Ruffner and was carried out by Mrs. Ruffner and Mrs. Harry Heap with the help of Chas. Vest and Earl Schuler.*

Speaker after speaker came to the podium to extol the virtues of the new Hassayampa Inn, including the entire board of directors. Judge Edmund W. Wells also spoke as an honor given to him, as he had come to Prescott in 1864, when the town was founded, and was probably the last original town resident still alive. Architect Chris Totten was presented with an engraved gold watch for his work.

W. Banks Tanner, an hotelier from Los Angeles, had secured the lease to run the new Inn, and he put his son, E. Paul Tanner, in charge as manager. On November 27, the *Arizona Journal Miner* newspaper included a multipage section devoted exclusively to the virtues of the hotel. The Hassayampa Inn was the biggest social event to occur in Prescott in some time. In the end, the hotel had cost $213,000 to build (in 1927 dollars), and the Tanners spent $75,000 on its furnishings.

On November 29, a large twenty-five-foot-long electric sign bearing "Hassayampa" vertically and "Inn" at the base was installed. It had been manufactured by an outfit called Electrical Products Corporation in Los Angeles and can still be seen on the Hassayampa Inn today.

The Hassayampa Inn has been open ever since, although the road hasn't always been easy for it. In later years, there was a period when it devolved into lower-class housing, but it has since been restored to its opulent splendor and continues to serve tourists and visitors to Prescott today.

A 1928 photo of the lobby at Hassayampa Inn. *Courtesy of Hassayampa Inn.*

As an old hotel, the Hassayampa has its share of paranormal activity throughout the whole hotel. Who are the ghosts at the Hassayampa Inn? The pervasive legend is that a newlywed bride named Faith Summers and her groom checked into room 426 on their wedding night, very shortly after the hotel opened in 1927. The husband (who is never named) stepped out to buy cigarettes and never returned. Despondent, Faith wandered the lobby for several days and then went upstairs to their room, walked out onto the balcony and hanged herself from the flagpole that used to hang on the balcony. She also may have committed suicide by hanging herself in the hotel's tower (both versions of the legend are active).

It is quite a striking story, but as with Abby at the Hotel Vendome, historians have searched for years to find corroborating evidence for the tragic event and have come up empty. There is no death record, no newspaper notice, no grave, no marriage license—nothing to prove that Faith Summers ever existed. If such a horrific tragedy had truly occurred, there would be *something*, right? It is also said that because of the importance of this exclusive hotel and the businessmen who were coming to Prescott, a story like a hanging would not be good for business and may have been hushed up by the press and hotel. In 1927–28, it was very easy to cover up something of this nature.

Those who believe the story to be true say that Prescott officials took extraordinary steps to cover up the tragedy so the beautiful new hotel's reputation would not be damaged, including the disposal of any records pertaining to her. But this type of accusation is brought up everywhere in the world whenever documentation does not match a popular legend. It is also noteworthy that Faith's story bears strong similarities to that of Abby at the Vendome—the wife abandoned by a nameless husband who then proceeds to do herself in. In doing research of Prescott, before starting her haunted and historical tours, Wilson found that it was not uncommon for a man to go missing, to drop off the face of the earth. Men were getting mugged and rolled for their money, buried and never seen again. Prescott was one of the wildest Old West towns in America at that time, and gambling, mining and drinking were the chosen activities.

But the Hassayampa Inn is a hotbed of paranormal activity. If the ghost isn't Faith, who is it? Psychics investigating room 426 have come away claiming that someone indeed died violently in there, and paranormal investigators also have come away saying that they believe the story of Faith to be true.

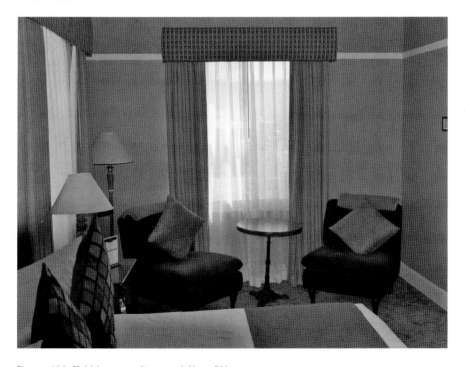

Room 426, Faith's room. *Courtesy of Shane Phipps.*

Wilson has had her own experiences in room 426, as well as other places in the Hassayampa Inn. When visiting friends stayed in the Hassayampa, they met for lunch at the Peacock Dining Room located in the hotel. The manager came over and asked if they would like to see Faith's room. Of course, they said yes and proceeded up to room 426. The manager told them to notice the smell in the hallway and the smell in Faith's room. The aromas were different. The smell in Faith's room was like a floral toilet water, the type of perfume they used back in the 1920s. The manager said that in all the years since Faith's death, they have tried to get rid of that smell. No matter what they do in that room, the floral smell always comes back.

The manager left the group in the room, and Wilson was telling her friends the story of Faith when something or someone started touching her pant leg. She said to a friend that someone was pulling on her pant leg, and she took a picture. There was an orb on her leg. Was that Faith?

Another room 426 story concerns how a paranormal investigator stayed in Faith's room. At midnight, she went to bed, and at 1:00 a.m., everything came on: the lights, radio and TV. She got up, turned everything off and went back to bed. She felt someone sit down on the side of her bed, so she used her leg to scoot them off. A few minutes later, she felt them sit down again. Again, she scooted them off the bed. Then she heard water running in the bathroom and a sound like a glass is being filled with water. She put her hands over her face, spreading her fingers so she could see what was happening; she saw a glass in midair—tipping, tipping, tipping and then *poof*, it disappeared.

A paranormal group from California stayed at the hotel to debunk the stories, but it couldn't debunk anything. In fact, the group added stories—it had so many things happen on its visit. Several of the investigators experienced what sounded like a sigh or exhale of breath. A shadow figure was seen and a growl was heard in that room by another investigator. In the basement and laundry room, an apparition of a boy was seen by two investigators, the sounds of footsteps were heard running, several sounds of something moving in different locations were heard and pant legs were felt being tugged on. The door to room 426 (Faith's room) opened on its own, as did the doors to the parlor room and the bathroom in room 425.

The Night Watchman is another ghost/spirit that coauthor Wilson met on one of her tours. He sits in the lobby and has been seen by many staff members. A hostess reported that she closed the dining room late one night, walked up the stairs to the lobby and saw a man in a brown coat sitting at the round table by the pianos. She asked him if he wanted

An orb in the lobby by the original elevator. *Courtesy of Darlene Wilson.*

the lights turned on, but the man did not respond. She turned to switch on the lights, and when she looked over where the man was sitting, he had vanished.

There was a family from Atlanta, Georgia (Ann and Michael and their three sons), staying at the Hassayampa Inn, and they participated in Wilson's tour. Throughout the whole tour, she knew that they were interested in the history of Prescott, but she had no idea how they felt about ghosts.

When they returned to the hotel at the end of Wilson's tour, Ann asked her if Michael had told her about waking her up at 3:00 a.m. Michael then went on to say that he woke up at that time and saw someone sitting on their counter in their suite. He said that it looked like a tiny person, like a leprechaun, so he got out of bed, started walking toward the leprechaun and got within two feet of it when it just disappeared. That's when he screamed and woke up his wife. Wilson said that he might be happy to know that one of the ghosts seen in the hotel is a little Chinese boy. Michael said that whatever it was, it was definitely there and then disappeared.

One night, on Wilson's tour with a paranormal group from Phoenix, she sat at the round table in the lobby in the exact chair where the Night Watchman has been seen. She said to Barry, the lead investigator, "You might want to take my picture. There is someone standing behind me." Barry took three pictures (always take three pictures—if it's a reflection it will show up in all

Lobby table and chairs where the Night Watchman has been seen and felt. *Courtesy of Darlene Wilson.*

three pictures; if it's a ghost, it will only show up in one picture). In one of Barry's pictures, there was the ghost of a man standing in the corner behind Wilson. Was it the Night Watchman? She believes that it was.

Then one of the employees came over to the paranormal group and said that she wanted to take us downstairs to the basement, to the housekeeping department. She said that sometimes at 3:00 a.m., you will hear a stampede of people running through the area when no one is there. It is closed, dark, and no one is working. She left them there, and they were standing and talking when Wilson felt someone tap her on the shoulder. She said to Barry, "There's someone here; he says his name is Silas, and he was a miner who died in the fire of the hotel that was here before this one." At that time, she didn't know there had been a hotel here before the Hassayampa Inn. When she got home, she did some searching on the computer and found a newspaper article that noted that the Congress Hotel had been at that location and had burned down in May 1924; the fire started at 3:00 a.m. The article reported that there had been twenty-four guests and that they all got out safely, but it never mentioned the employees working there. Wilson knows of three ghosts in the Hassayampa Inn that died in that fire.

People who stay there have shared their stories of toothbrushes moving, unusual smells in the corners or closets and smells of old perfumes and aftershave not used today. Clock radio alarms going off when the clock is not plugged in. Some famous people who have stayed at the inn include Tom Mix, Will Rogers, Greta Garbo, Clark Gable, General John "Black Jack" Pershing, Tom Selleck, Steve McQueen, Sam Elliott, Joan Rivers, Kim Basinger, Alec Baldwin, Hugh Downs, the Beach Boys and Tom and Dick Smothers, to name a few.

HOTEL ST. MICHAEL

The picturesque Hotel St. Michael sits at the north end of Whiskey Row, directly across from the west side of the Courthouse Plaza. On this site originally was the Hotel Burke, constructed around 1890 by local businessman Dennis Burke and his partner, former Yavapai County lawman Michael J. Hickey.

Dennis Burke had been a former mayor of Prescott, who also was a military veteran of the Indian Wars and also had served in the Arizona territorial legislature. His advertising for the Hotel Burke boasted that it was

A historical picture of the lobby of Burke Hotel/Hotel St. Michael. *Courtesy of Sharlot Hall Museum.*

completely fireproof (apparently a jab at other hotels and rooming houses in Prescott), but this claim would come back to haunt him.

Burke's partner and co-proprietor, Michael J. Hickey, had been a Yavapai County deputy who assisted in the legal hangings of murderers Dennis W. Dilda and Frank Wilson in 1886 and 1887, respectively. He had also worked on cases stemming from the crime-ridden Antelope district in southern Yavapai County in the early 1880s, where "boss" Charles P. Stanton was believed to have been responsible for many depredations. Some revisionist historians have tried to depict Hickey as a corrupt police officer who was bought and paid for by the Stanton faction, but there is little evidence to support this. After leaving law enforcement, Hickey went into business and became a partner in the Hotel Burke.

On July 14, 1900, a fire broke out on Montezuma Street, and all of Whiskey Row and some surrounding areas burned to the ground, including the Hotel Burke. This tragedy became a defining moment in Prescott history, and the citizens banded together to rebuild from the ground up, as almost all of Prescott's business district was now ashes.

Burke and Hickey decided to rebuild the Hotel Burke, but this time around, they hired architect D.W. Millard to design a much larger brick structure with more rooms and a dining hall. The new Hotel Burke was opened to visitors in the summer of 1901 (contrary to popular belief, the name change to St. Michael did not occur at this time).

On April 15, 1907, Michael J. Hickey bought out Dennis Burke's share of the hotel and became sole proprietor. It was he who changed the named to Hotel St. Michael on May 17, 1907. The hotel had daily ads in the newspapers, and it was on this date that the new name first appeared.

Eventually, Hickey sold out to Ed Shumate, and ownership later went to John Duke, who spent much money on upgrades to the St. Michael in the 1920s, including installing an elevator and putting telephones in the rooms.

Today, the Hotel St. Michael still exists and does brisk business. If you look at the structure and glance up near the roof, you can see one of Prescott's strangest and most enduring mysteries. Surrounding the building near the roof is a variety of truly ugly gargoyle faces. It must be presumed these were designed by architect Millard with the approval of Burke and Hickey, but

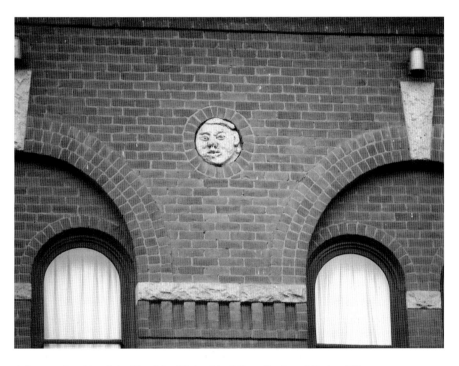

A face on the side of the Hotel St. Michael building. *Courtesy of Darlene Wilson.*

there seems to be no surviving documentation as to what these faces are supposed to mean. They are unlike any other building design in Prescott. Popular lore in Prescott speculates that they were intended as caricatures of local politicians; this is as good an explanation as any, but there is no surviving source for this. Perhaps Burke and Hickey just wanted to be "different."

The Hotel St. Michael is believed to be haunted, but unlike the Vendome and the Hassayampa, the management does not like to talk about this. Coauthor Wilson has heard stories from people staying at the hotel and others who have shared their experiences. One she heard over and over is about a lady that haunts the hotel. Footsteps are heard in the halls, and one gets the feeling of being watched.

Another story is about a couple who went for a weekend trip to Prescott, where they stayed at the Hotel St. Michael. They sat on the bed to watch TV. The man had his feet dangling off the end of the bed, and all of a sudden, he sat right up. He said that something cold had passed by his foot, and his foot was still tingling. Later that night, they were heading out, walking down the empty hallway, and they could smell the strong odor of a woman's perfume. It was an old type of perfume, something the lady's grandmother would have worn, like powdery lilac. In the middle of the night, the man woke up and said that, as clear as day, he heard a woman say, "Show your face." It sounded like it came from the end of his bed. He said that it wasn't scary—almost playful, actually.

Another couple reported that they stayed in room 228. They checked in at 6:00 p.m., and around 7:00 p.m., there was a knock on their door. He got up to open the door, but before he got there, a young lady opened it instead. She asked if there was a certain person in their room. They said that this person was not in their room. At that point, she closed the door. Jeff opened it immediately and looked down the hall, but she was gone. When they went downstairs shortly after that, they notified the lobby clerk that someone had tried to come in their room. The clerk in the lobby said that it was not possible since they had the only key. When they went back up to their room, the window was wide open, and the air conditioner was set at fifty-five degrees. It was the middle of January and freezing outside.

Ghosts of children have been heard playing in the elevator—usually late at night, when all is quiet, except for the kids. They love riding the elevator, but what kid doesn't?

Historical Marker: Hotel St. Michael

The cornerstone of historic "Whiskey Row," the Hotel St. Michael, represents the coming of age of Prescott's hostelries. Constructed on the site of the modest Hotel Burke, which burned in 1900, the new three-story hotel was designed by D. W. Millard in the Second Renaissance Revival style. Built of brick and stone, it is decorated with stone faces or "gargoyles," which allegedly represent crude images of local politicians. Opened June 1, 1901, the hotel offered "gracious accommodations" and the most advanced amenities of the era. Significantly, the hotel has hosted many distinguished visitors, including President Theodore Roosevelt, John L. Sullivan, Jake Kilrain, Tom Mix, Zane Grey, Senator Barry Goldwater. The Hotel St. Michael is an excellent example of early twentieth century western style accommodations in Prescott and today presents a reminder of Prescott's colorful historic past.

Funded by the Historic Preservation Fund and the City of Prescott

AJ Head Hotel/Downtown Prescott Inn

Just after the Great Fire of 1900, this eighty-room, three-story hotel was built and called the AJ Head Hotel, with balconies on the second and third floors overlooking Cortez Street and all the activities of downtown Prescott. In the lobby of this historical and haunted hotel, you will find bullet holes in the ceiling. At the turn of the century, cowboys were known to raise a little ruckus by riding their horses into downtown buildings, pulling their six-shooters, blasting holes in the ceilings and then riding out. This was a regular habit and their way of letting off steam. That answers some of the questions of bullet holes in the tin ceilings at least.

More than half the guests who stayed at the AJ Head Hotel shared incredible stories and experiences while staying there. One of the ghosts that is seen often is a woman in white walking the halls. Also, a cowboy wearing two six-shooters and spurs has been seen, and footsteps and spurs are heard clattering down the halls. Strange noises are heard all the time,

Downtown Prescott Inn. *Courtesy of Darlene Wilson.*

Bullet hole in the ceiling of the Prescott Inn. *Courtesy of Parker Anderson.*

and those who go to investigate the sounds in the hallway never see anything. Several people have died in the hotel over the years, and many still haunt the Downtown Prescott Inn in Prescott, as it is known today.

A woman was killed on the first floor and is still at the hotel. She can be heard yelling and screaming right before she dies. Another cowboy walks up and down the halls and up and down the stairs, shutting doors behind him.

The AJ Head lost its historic integrity when it was renovated in the 1980s. It is still a beautiful building and still has balconies overlooking Cortez Street. Do you think the ghosts hang out there, seeing the streets as they once were?

HISTORICAL MARKER: HEAD HOTEL

Colonel C.P. Head was in the hardware business in Prescott by about 1866. By 1875, Colonel Head was involved in several businesses including hardware, lumber and a hotel. He served in the territorial House of Representatives from Yavapai County for the 1875–1877 term. Colonel Head was described by William A. Farish as "a most excellent gentleman, a business man of wealth." By 1916, there were 16 hotels in Prescott, including the 80-room Head Hotel. Built by A.J. Head just after the fire of July 14, 1900, the "grand brick" hotel was 3 stories high and had pairs of windows looking out onto the street with 3 sets of balconies on the 2nd and 3rd floors. Unlike many hotels of the time, the Head hotel boasted steam heat and hot and cold water in every room. Twenty rooms had private baths. Rates were by the day, week or month. The first floor was primarily commercial, except for the lobby. The hotel offered a restaurant, floral shop, newsstand and barber shop. Business included the Post Office, Calles' Saddelry, the New State Theater, Andres' Cigar Shop and various retail stores including, in later years, J.C. Penney's.

HAUNTED HISTORICAL BUILDINGS

ELKS OPERA HOUSE

Not quite one block from the courthouse on East Gurley Street is the Elks Performing Arts Center, more popularly known by its original names, the Elks Opera House and the Elks Theater. It is a large, three-story edifice, constructed and opened in 1905 by the Prescott branch of the Elks Lodge, No. 330 BPOE. It consisted of a theatrical auditorium on the first floor and lodge rooms for the Elks on the third floor, while the second floor hosted various things over the years. For a while in the World War I era, the United States Federal Court was located on the second floor.

Prescott Elks Lodge No. 330 sold the building in 1968 and moved out three years later, although it has retained its historical name ever since. It has gone through a variety of owners in the ensuing years. The early 2000s saw efforts to raise money to restore the increasingly deteriorating theater to its original grandeur; the efforts came to fruition in 2010 with a beautiful restoration, partially financed by a grant from the Harold James Trust.

There has never been a significant period of time that the Elks Opera House was ever closed, making it one of the longest consistently running entertainment facilities in America. It has hosted plays, operas, concerts, political rallies, boxing and wrestling matches and church services. However, despite occasional live shows during the period, the Elks Opera House spent seventy-two years of its existence (1910–82) primarily as a

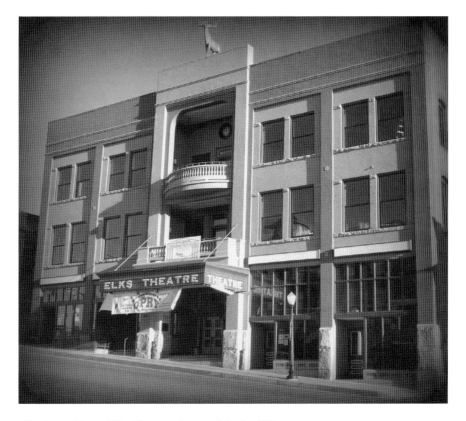

Elks Opera House/Elks Theater. *Courtesy of Darlene Wilson.*

movie theater. Old-time Prescott residents still have happy memories of going to the movies at the Elks.

Many people who have worked at the Elks absolutely believe the theater to be haunted, and they don't like working there alone at night. A former manager once told coauthor Anderson that she occasionally heard faint operatic voices singing in the theater at times when she was there alone.

Quite a few years ago, a story circulated that workers involved with the 1980–81 remodeling of the theater heard the sound of glass tinkling late one night. They looked up and saw the transparent figure of a little girl swinging from the chandelier. This story, unfortunately, cannot be corroborated.

One of the funnier ghost stories connected to the Elks Opera House began to be told in the 1980s. It contended that the center stall in the women's restroom was haunted—*specifically* the center stall. If you used it, the story went, you ran the risk of the ghost speaking to you while you were doing your

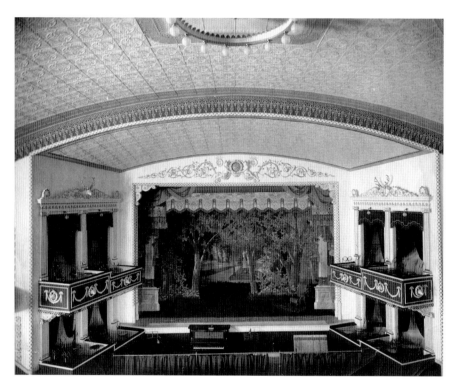

A historical picture of the opera house. *Courtesy of Sharlot Hall Museum.*

business. This story seemed to die out for a while, but the restroom ghost may be making a comeback. Recently, an employee told Anderson that she was using the restroom when, suddenly, the stall door unlatched itself and the door flew open—with no one else there. He believes her, as she is not someone who would make up something like that. Shortly after the 2010 remodeling of the theater, an usher told him that at one performance, she saw a ghost sitting in one of the newly restored box seats watching the show. He was dressed in period clothes. He asked the usher how she knew it wasn't just some man sitting there. She couldn't explain it—she just somehow *knew*. This type of "knowing" is actually consistent with specter sightings, even if they aren't transparent at the time.

Current staff members have told the authors that they have encountered foul odors in the theater (a fairly common phenomenon at haunted sites). They have also been occasionally pushed and had their hair pulled while they were alone. One theater volunteer told the authors that she has actually seen apparitions twice in the facility—one being a man dressed in black and

Orbs in box seats at Elks Opera House. *Courtesy of Darlene Wilson.*

the other a man in a cowboy outfit (it is interesting to note that a phantom in a cowboy outfit has reportedly been seen at the Hotel Vendome as well). The Elks Opera House staff have named the ghost "Fillmore."

The authors were also told by current staff that a few years ago, a cleaning lady in the theater reported that she actually spoke to the ghost. The spirit told her he thought the nickname of Fillmore was "cute" but that his real name was Robert. This represents one frustrating thing about hauntings: on the rare occasions that ghosts speak to the living, they are very ambiguous about their identities.

On January 19–20, 2018, the authors shadowed a ghost hunter group, Southern California Paranormal Research and Investigations, which was investigating the Elks Opera House. The members of the group picked up some voices on their EVP devices, but the most spectacular thing occurred when everyone left the theater for a few hours for supper. The assistant manager had turned out the lights when they left, and when she returned, they were back on. Upon examining the video the paranormal group had

left running, it was determined that the lights came back on, with no one in the theater, only four minutes after we had departed.

As you can see, the ghost stories connected to the Elks Opera House are not overly consistent with one another. This would suggest, perhaps, many phantoms, or possibly various spirits coming and going over the years who simply liked the place. One may ask if there are any known stories of tragedy at the Opera House that might explain the hauntings. Certainly there are legends—a despondent actor who hanged himself on the stage one night or a little girl who fell to her death from the balcony once upon a time. Still another story states that during a renovation, or perhaps during some plumbing work, human bones were found inside one of the walls. There is no documentation for any of these stories, and at this point, they should be regarded as folklore. Many old theaters have similar legends.

But there are indeed two tragedies connected to the Elks Opera House that are fully documented. In 1912, a Russian immigrant who went by the name of Professor Stanislaus Scherzel (no one knows for sure if he was a real professor) was hired to play classical music on his violin each evening before the motion pictures would start. But Professor Scherzel was seriously depressed, and one Sunday afternoon, he shot himself to death at his home, following a fight with his wife, Emily. Could he be one of the spirits that haunts the Elks? He was buried in a cold, unmarked grave in Mountain View Cemetery in Prescott—this treatment was often the custom for suicides in those days. In 2005, a group of Prescott historians got together and arranged for a marker to be placed at his grave.

The employees say that the cleaning staff have heard someone playing a violin after a play or concert at the Elks Theater. On one of coauthor Wilson's tours one night, they had a lady who worked at the Elks, and she asked her if she had ever heard the violin music. She said, "No, but we outsource our janitorial service, and we get a lot of them that won't come back." Wilson asked her if she had ever heard anything, and she said that she'll hear conversations going on outside her office in the hall; when she gets up to check, there's no one there.

Later in 1912, Benjamin Belcher, the first manager of the Elks Opera House and longtime treasurer for the Prescott Elks Lodge, checked into a Prescott hotel and committed suicide by either ingesting, or smothering himself with, chloroform. He did this, ironically enough, on Halloween. Belcher was a pillar of the community, and his family and doctors conspired to cover up the cause of his death from the community in order to save his reputation. They informed Prescott's newspapers that he had succumbed to

Professor Scherzel's headstone. *Courtesy of Darlene Wilson.*

an attack of Bright's disease. The truth came out more than fifty years later when his death certificate became public record. Could he perhaps be one of the Elks Theater specters too?

Footsteps and voices are heard when no one else is there. Toilets flush, and water as well as lights are seen or heard being turned on and off. A small child giggles, and the employees try to find where the laughter is coming from but can never find it.

SHARLOT HALL MUSEUM

Three blocks west of the Courthouse Plaza, at 415 West Gurley Street, is the block-long campus of Prescott's best-known historical museum.

Sharlot Mabridth Hall was born in Kansas in 1870, and as a child, she accompanied her parents to the Arizona Territory by wagon train, where the family settled on a ranch (named the Orchard Ranch) near what is now

the town of Dewey-Humboldt. But in an era when young women were traditionally expected to become nothing more than wives and mothers, Sharlot exhibited a strong independent streak—she was drawn to writing poetry while still a child, and after listening to stories told by Prescott's old-timers, she became interested in historic preservation, an idea that was far ahead of its time in the early twentieth century.

Sharlot Hall began soliciting stories from Arizona pioneers who were still living about what life was like in the territory's early days. She actively campaigned for Arizona statehood at a time when others were starting to give up hope that the American territory would be added to the Union as a state. (Washington had long been resistant to Arizona statehood, believing that its citizens were too wild and unseemly.) Most of all, Sharlot believed that it was of paramount importance to preserve the old Governor's Mansion in Prescott, which still stood, albeit in varying states of decay.

When the first Governor's Party arrived in the newly formed territory of Arizona in 1864 to set up a government and establish a capital, a large (for its day) four-room log cabin was built for Governor John N. Goodwin to live in. He lived on one side of the mansion, while Secretary of the Territory Richard C. McCormick lived on the other side. When Goodwin left for Washington in 1866 to become Arizona's delegate to the U.S. House of Representatives, McCormick became governor and continued to live in the mansion with his wife, Margaret.

Young Margaret McCormick was well liked by the citizens of the small village of Prescott, and they were deeply grieved when she died in childbirth

Governor's Mansion, Sharlot Hall Museum. *Courtesy of Darlene Wilson.*

in the mansion in 1867 (her baby died as well). She was originally buried on the grounds of the mansion, but her family later had her body exhumed and reburied in her home town of Rahway, New Jersey.

In 1867, Governor Richard McCormick signed a bill passed by the territorial legislature to move the Arizona capital far south to Tucson, only a scant three years after it was established in Prescott. Many believed that he did so to curry favor with Pima County for his own planned campaign to become the territory's delegate to the U.S. House of Representatives (which he subsequently achieved). With the Arizona territorial government gone from Prescott, the Governor's Mansion became a private residence for Henry W. Fleury, who was personal secretary to both Goodwin and McCormick. Fleury seemingly disapproved of the government's move and stayed in Prescott, serving as justice of the peace and living in the mansion until his death in 1895. After that, the historic structure was used as a cheap boardinghouse and even served as a laundry for a while, becoming increasingly dilapidated over the years.

Sharlot Mabridth Hall recognized the need to preserve the Governor's Mansion and campaigned for this cause over many years. Her dream came true in 1927, when the property was acquired by the City of Prescott and turned over to her care. In the summer of 1928, Sharlot Hall, who started out as a farm girl, opened the mansion to the public as a museum, displaying artifacts she had collected over many years.

In the ensuing years, Sharlot added to her museum. She arranged to have Fort Misery, believed to be the remains of the first log cabin built in Prescott, moved to a site only a few yards away from the mansion. She was involved in having the remains of Pauline Weaver, an old army scout and mountain man who arguably arrived in the Arizona Territory when it was still mostly uninhabited, exhumed from the San Francisco National Cemetery and reburied only a few feet from the mansion. Sharlot arranged to have other buildings constructed on the property as WPA work projects in the 1930s, including an exhibit building and a replica of a typical ranch house.

Sharlot M. Hall lived in the Governor's Mansion herself and ran her museum until her death in 1943. After that, others took over and named the museum in her honor. Sharlot Hall Museum has since grown even bigger in later years, including the construction of a large museum center in the 1970s, as well as the moving of two historic homes, the dwellings of territorial governors Coles Bashford and John Charles Frémont, to the museum grounds to save them from demolition. Today, Sharlot Hall Museum

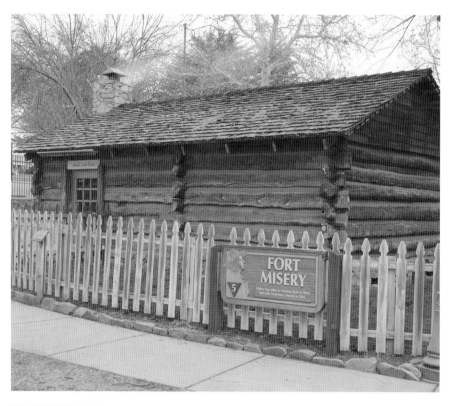

Above: Fort Misery, Sharlot Hall Museum. *Courtesy of Darlene Wilson.*

Left: Pauline Weaver's headstone. *Courtesy of Darlene Wilson.*

consists of a block-long campus, including workshops and an amphitheater. It remains a major draw for tourists, particularly in the summertime.

With so many old buildings on the campus, dating back to the 1860s, it is not surprising that supernatural phenomena have been reported at Sharlot Hall Museum. While such reports do not come as often here, they do exist. An assistant archivist once told coauthor Anderson that she was once working at her desk, looking down at some papers, when she saw something out of the corner of her eye: a well-dressed woman walked past her. Immediately looking up to address the woman, she saw that there was no one there. Others have reported similar sightings, such as shapes off to the sides that vanish when you turn to look at them straight on. Other workers have reported finding objects in the buildings moved overnight to different locations when there would have been no one around to move them.

Anderson has also been told by volunteers who sit in the various buildings to keep watch on visitors that, occasionally, someone who professes psychic powers will exclaim that they sense ghosts in the buildings. If so, the spirits seem to be generally quiet and non-mischievous. But who are they? Sharlot Hall herself immediately comes to mind and possibly also Henry W. Fleury, or perhaps the tragic Margaret McCormick, who died in childbirth in the Governor's Mansion at such a young age.

Back around 2010, a group of paranormal investigators requested and received permission to do an investigation at Sharlot Hall Museum, on the condition that museum volunteers follow them around to make sure they did not inadvertently damage anything. That night, the group broke up into several units, each exploring a different building with infrared cameras and EVP equipment. Anderson shadowed the group that went into Fort Misery. Shortly after turning out the lights, so it was almost pitch dark, a psychic who was part of the group suddenly noted that there was a ghost sitting on the bed in the front room (the bed being part of the building's display). She started talking to the spirit, which no one else could see except her. The psychic then informed the group that the ghost was a young woman, waiting for the spirit of the man she loved to come to escort her to "the other side."

The psychic then informed the spirit that her lover was already on the other side waiting for her. Then she turned to the group and said sadly, "She doesn't believe us!" The psychic continued to try to talk the spirit into leaving. Around this point, somebody tried to enter Fort Misery from the outside, only to have the door slammed in his face by one of the ghost hunters, who hissed, "Stay out! We are conducting an *intervention*!" In the end, the psychic was unable to persuade the spirit to leave Fort Misery.

Anderson came away from this experience somewhat skeptical of what he had witnessed from this group. The thing that bothered him the most was that the psychic made no attempt to elicit any identifying information from the ghost, such as asking her who she was and when she had died, which could be used for corroboration later.

MASONIC TEMPLE

John Noble Goodwin was appointed by President Lincoln to be governor, taking the place of John A. Gurley, who died before he could take office. Governor Goodwin was a Freemason, and in 1864, nine master Masons held a meeting at Governor Goodwin's house and decided to apply to the Grand Lodge of California to open a lodge at Prescott. The name chosen for the new lodge was Aztlan. John T. Alsap became the first mayor of Prescott and the first lodge master.

October 1868 was when the Freemasons chose a new lodge located on the southwest corner of Montezuma and Gurley Streets, where the Hotel St. Michaels is located now. The lodge room was located above the Diana Saloon.

In 1907, the Freemasons built a permanent building now located at 107 North Cortez but later moved to their current location on Willow Creek Road. But in July 1867, the building that was at the Cortez Street location before the Masonic Temple was the old courthouse, the first courthouse. It was a two-story shack where the legislature met while waiting for the red brick courthouse to be built. According to *Prescott: A Pictorial History* by Melissa Ruffner, the building also housed the jail and Sheriff's Office on the ground floor and a community meeting hall/courtroom on the second floor. Legal executions were carried out in the fenced yard behind the courthouse. Early church services were conducted here, and in later years, it became the Bellevue Hotel.

The building is haunted, or so the cleaning lady says. She hears noises all the time—someone walking around upstairs and doors slamming shut even though no one else is in the building. One evening, her husband was there helping her with cleaning the building when he noticed a woman going into the ladies' restroom. When the cleaning lady went to get her husband so they could leave, he told her that a woman had gone into the restroom, so they waited. Finally, the cleaning lady went into the women's restroom, but

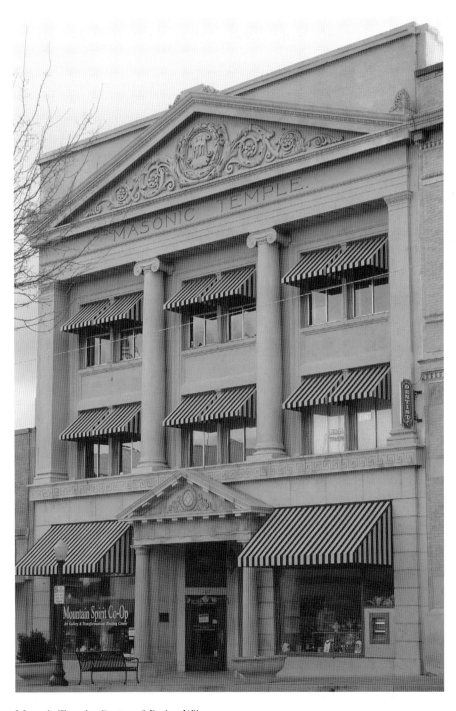

Masonic Temple. *Courtesy of Darlene Wilson.*

all the lights were out and no one was there. The husband told her that he definitely saw a woman enter, and his wife replied, "No worries, it happens to me all the time."

During coauthor Wilson's haunted tour, they always go into the alley behind the Masonic Temple building. Interesting things happen there all the time. One person on her tour got a picture of a Templar knight. The Freemasons are believed to be descendants of the Knights Templar, and the picture definitely looks like a knight holding a sword. Everyone else on the tour took dozens of pictures and got nothing.

Because of the hangings that possibly took place behind the building, a lot of interesting pictures are produced. The people who were hanged in that location were murderers, and because of their crime, they did not get headstone or markers on their graves. But because of the energy of death and the emotions that linger there, there is quite a bit of activity. Some people get tapped on the shoulder, and once a young lady was pinched on the leg while on the tour. She went back the next day during the daylight to see if anything would happen, and she got pinched again. She does not ever want to return to that alley.

Another night on a tour, two men walked down a few of the steps, stopped and began talking to each other. One of the ladies on the tour took three pictures down the stairs while the men were standing there. When she looked at the pictures, the stairs showed up in all three pictures—the men only showed up in one picture. What happened to them in the other two pictures? Why were they in only one of the pictures?

The Arizona Pioneers' Home

The mission of the Arizona Pioneers' Home was to provide a home for Arizona pioneers and disabled miners that delivers optimal physical, emotional and spiritual care in a homelike environment. It started as a continuing care retirement home operated and funded by the State of Arizona. Initially, the home was built to house forty men, but in 1916, pursuant to a benevolent donation, an addition of a women's wing was completed to provide for twenty women. Later, in 1929, the home was again expanded to include Arizona's Hospital for Disabled Miners.

It opened its doors in 1911, and one visitor who dropped in and called on the pioneers was none other than Buffalo Bill Cody. He was in town

Arizona Pioneers' Home. *Courtesy of Isabelle Barnes-Berutts.*

to check out possible mining businesses in Prescott. He loved the area and dropped into the Pioneers' Home, pleased to see pioneers there whom he knew personally or by reputation. He said that one of the happiest times he spent in all his travels was his time in Prescott, Arizona.

Today, the Home can care for up to 150 residents and operates via appropriations of about $5 million annually through state land trusts, a miners' hospital fund, state charitable funds and the general fund. The current population of residents includes individuals from throughout the state of Arizona.

"Big Nose Kate," born Mary Katherine Horony, was from Budapest, Hungary, and was the daughter of a physician. She was highly educated and could speak five languages. She was also Doc Holliday's on-again, off-again girlfriend (Mary Katherine Cummings lived, died and is buried in Prescott). The bond between the two was always intense, and she was with him when he died in Glenwood Springs, Colorado. She returned to Arizona, where she lived in Cochise, Arizona, for thirty years, and decided she wanted to retire in Prescott at the Pioneers' Home. Because she hadn't lived in Arizona fifty years or was a U.S. citizen, she had to get a "friend" of hers to write a letter

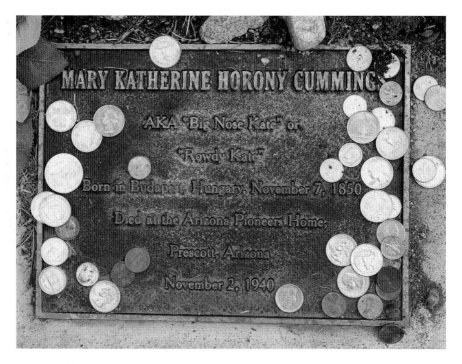

Big Nose Kate's grave. *Courtesy of Darlene Wilson.*

to get into the home. Her friend was the governor. She spent her later years in Prescott, Arizona, living in the Arizona Pioneers' Home, where she died one week before her ninetieth birthday.

Kate was a larger-than-life character who lived to see stories of her own life and supposed death. In real life, she died in bed, having survived a world that was hard on women. Kate never denied that she was a rip-roaring, hard-drinking, gun-slingin' prostitute. She was an independent woman who saw prostitution as a way to be in control of her own life, answering to no one. Kate said that she could "out gamble, out spit and out shoot anyone."

Was John Miller Billy the Kid?

In 1937, John Miller checked into the Pioneers' Home. After his wife's death, declining health and a fall from the roof of his home, his son brought him here. He died eight months later, before he could "set the record straight."

John Miller would sit around and tell stories that only Billy the Kid would have known, and when he died and they eventually went through his trunk, they found items in there that could only have belonged to Billy the Kid. A court representative who had gone through Miller's trunk said that the contents of the trunk proved that Miller was the Kid. With no heirs to be found, the whereabouts of the trunk are unknown.

The story is that Pat Garrett shot and killed Billy the Kid in New Mexico. No one saw whom he shot and buried, but Pat Garrett and Billy the Kid were, famously, good friends. It would make sense that Garrett would tell Billy to run, change his name and start a new life. The first known existence of John Miller came in 1881, when he married a Mexican girl in Las Vegas, New Mexico. He was reported to be weak, with a relatively fresh bullet wound visible through his shirt. He also had a talent in working with horses, a gift William H. Bonney had as well. A photograph has surfaced that may be of Billy the Kid with Pat Garrett. After much testing, it is believed that the picture was taken between 1879 and 1880. Facial recognition software indicated that it most likely is Garrett and the Kid. The signature on the card by Garrett matches several letters written by him.

Is John Miller the real Billy the Kid? He is buried in Prescott at the Pioneers' Home Cemetery without a headstone or marker. In 2006, two men exhumed the remains of John Miller. Charges were not sought because the men had permission from the Pioneers' Home, though not the State of Arizona officials, or so the story goes. The men did get samples and sent them to a Dallas lab to compare Miller's DNA with blood traces taken from a bench that were supposedly from Kid's body after he was shot in 1881.

One of the men, last name Sederwall, refused to disclose the results of that DNA test for fear of provoking attacks from historians. He said, "What I know is not what's written in history. What I know differs from history," as reported by the *Washington Post*.

Is the Arizona Pioneers' Home haunted? The staff responds with a definite *yes*. Footsteps are heard at night when everyone is asleep, but the creepiest thing a staff member said was that they have a TV room where residents gather to watch a movie and hang out together. After the movie ended, everyone went to their rooms, but they left the TV on. The staff member went over and turned off the TV. As she walked out of the room, the TV came back on. She went back over, turned the TV off and started to leave the room again, but it came back on. So, she decided to fix it for sure, walking back over to the TV and reaching down to unplug it. But it wasn't even plugged in! Needless to say, that freaked her out.

Spirits stay around for many different reasons—perhaps because they don't realize they're dead, they like being here, they have unfinished business or they committed suicide. Whatever the reason, they have the same personality dead as they did alive. We don't always need to know why they are staying behind, but respecting them is important.

PRESCOTT CENTER FOR THE ARTS

The Prescott Center for the Arts theater (formerly known as Prescott Fine Arts Association) is located at 208 North Marina Street, roughly two blocks from the Courthouse Plaza. It is the oldest and best-known community theater in the Prescott area, performing many plays and concerts yearly, with an art gallery downstairs as well. Just walk down Cortez Street from the courthouse for one block and then turn right on Willis Street. One block up, at the corner of Willis and Marina Streets, sits the old Gothic brick building that looks like a church—indeed, it was the old Sacred Heart Catholic church in Prescott for many decades. Because of its appearance, people still periodically walk into the theater's office asking to talk to a priest.

The story of the Church of the Sacred Heart of Jesus in Prescott is almost the story of Catholicism in central Arizona itself. Roman Catholic tradition contends that the first Catholic priest to pass through the area that would someday become Prescott was Father Francisco Garces around 1776, from the San Xavier del Bac Mission near Tucson (then still part of Mexico). He was making a pilgrimage to the Hopi tribe to try and minister to them.

Catholic tradition further contends that in 1863, Archbishop Jean-Baptiste Lamy of Santa Fe traveled through what would soon become Prescott, stayed a few weeks and offered Christmas Mass for the regiments at Fort Whipple. As he left on Christmas Day, he paused to offer Mass again, using a stone at the base of nearby Granite Mountain as an altar.

Existing records show that the first Catholic Mass ever celebrated in the village of Prescott itself occurred on January 22, 1871. A visiting priest, Father J.M. Chaucot from La Paz, performed the Mass in a store owned by Manuel Ravenna that was located at the corner of Goodwin and Montezuma Streets.

In subsequent years, other priests visited Prescott to hold Mass for the growing Catholic population. By 1877, Archbishop Jean-Baptiste Salpointe had sent Father Michael Murphy, a native of Ireland, to Prescott to establish

Prescott Center for the Arts. *Courtesy of Darlene Wilson.*

a permanent Catholic church. Father Murphy arrived in October 1877, reportedly suffering from tuberculosis. He celebrated Mass a few times but passed away two months later on December 6, 1877, at the age of thirty-seven. He is buried at Citizens Cemetery.

In the ensuing years, a number of other priests came and went, attending to the Prescott flock. It is believed that Mass was held in a building at 227 North Marina Street, almost across the street from where the Sacred Heart Church would later be built. Among these priests was Father Franciscus X. Gubitosi, who counseled murderers Frank Wilson and Martin Duran before they were hanged in Prescott in the 1880s. He also performed the marriage ceremony of Prescott hero William O. "Buckey" O'Neill to Pauline Schindler in 1886.

Others followed, but it was the French-born Father Alfred Quetu who had the greatest impact. In 1889, Father Quetu came to Prescott to take over the Sacred Heart Parish. This would become the turning point for the church in Prescott, as Father Quetu did more to strengthen the local church than had any of his predecessors. Quetu set out to build a new church at

Sacred Heart Church, early 1900s. *Courtesy of Sharlot Hall Muesum.*

208 North Marina Street at a cost of about $6,000. Excavation of the site and construction of the basement commenced in 1891, but the church itself was not completed until 1894. The beautiful old Sacred Heart Church, considered by many to be one of the best examples of nineteenth-century religious architecture in Arizona, was designed by architect Frank Parker in "Sober Gothic Style," using pointed arches and decorative brickwork combined with local rough-cut stone. The church's 115-foot steeple was admirably executed, but it was eventually removed around 1932, possibly because it was being repeatedly struck by lightning. The first services in the new church took place on February 17, 1895. Eventually, a rectory was constructed next door, with a vestibule connecting the two buildings.

Father Quetu also oversaw the construction of a similarly designed Catholic church in the town of Jerome, started a Catholic parish in the town of Congress and began the educational facility of St. Joseph's Academy, with grades 1 through high school. As his predecessors had done before him, Father Quetu attended to the spiritual needs of murderers about to be executed in Prescott. He baptized the notorious outlaw Fleming "James" Parker the night before he was hanged on June 3, 1898, and also attended to the murderers Hilario Hidalgo and Francisco Renteria before their double execution in 1903.

On June 18, 1902, Father Quetu's assistant rector, Father Edmond Claessen, a Belgian immigrant, died of typhoid fever in Prescott. Little is known of his background, but he was much loved, and his funeral attendance was large. The parish erected a memorial to him inside the building, an act that may have led to a long-standing legend that he was buried under the altar of the church (he was actually buried at Citizens Cemetery).

Father Alfred Quetu, in failing health, left Prescott for good in 1908 and spent a few years at the Mission at San Juan Capistrano in California. He died on September 30, 1930, in old Carthage on the Mediterranean shores of North Africa.

The decades went by until the 1960s, by which time Prescott's Catholic population had grown so large that the beautiful church could scarcely hold them. It was decided to build a new, larger church on the site of the razed St. Joseph's Academy nearly one mile away. The old church at 208 North Marina Street held its last services on June 13, 1969, and was decommissioned and sold to the newly formed Prescott Fine Arts Association, with much of the financing coming from the group's benefactor, Norma Hazeltine.

By 1969, the legend that Father Edmond Claessen was buried under the altar had already come into existence, and Sacred Heart Church did not

want to leave him behind, so it obtained permission to have him exhumed. Much digging and excavating was done, but his remains were not found (this eventually led to an untrue legend, told by folklorists to this day, that an empty coffin was found, with no remains in it).

With the old church converted into a community theater auditorium, Prescott Fine Arts Association commenced producing plays and many other entertainment events, down to the present day. At the behest of Executive Director Jon Meyer, the name of the organization was changed to Prescott Center for the Arts on September 1, 2011. Coauthor Anderson has been involved with it for many years.

Many people swear that the old theater is haunted, and indeed it seems to abound in supernatural activity at times. When Anderson first became involved with the theater, the ghost was rumored to be female, and the staff had named her "Sophie." Eventually, the nickname became "Father Michael" due to speculation that the spirit could be the specter of Father Michael Murphy, even though he died long before this old church was built.

The current belief is that the paranormal activity is due to the ghost of Father Edmond Claessen, as he was believed to have been buried under the altar; many people believe his remains must still be there. Folklore has intruded on Father Claessen's story, and storytellers relate that he was a wandering, itinerant priest who was out in the wilderness ministering to the Indians. When he died, the story goes, the Indians brought his corpse into town for burial. This, of course, is not true.

Left: Stage and seating inside the theater today. *Courtesy of Darlene Wilson.*

Opposite: Father Claessen's monument inside the Sacred Heart Church. *Courtesy of Sharlot Hall Museum.*

IN MEMORIAM
REV. EDMOND CLAESSEN
Died on duty June 18th 1902
R · I · P

In recent years, solid research by historian Betty Bourgault has conclusively proven that Father Claessen was buried at Citizens Cemetery in 1902, next to Father Michael Murphy. He never was interred under the church altar. He surely had a tombstone at one time, although it vanished at some point, as many markers in this cemetery have. Once his burial place was established, a new marker was placed at his grave.

The staff of Prescott Center for the Arts have long reported unusual activity in the theater and in the old rectory next door, which today houses the theater's dressing rooms and offices. Strange knockings have been heard, and lights mysteriously turn on and off. Occasionally the activity is more pronounced. Coauthor Anderson has a close friend who was working alone in the theater one night, building a graveyard set for a reading of Edgar Lee Masters's *Spoon River Anthology*. An artificial moon was hung above the set, and at one point, she looked up and saw the shadow of a cowled figure move across the moon.

Another friend told Anderson at one point that she had been working on a large-scale production of *The King and I*, and one night, a little boy in the musical chorus disappeared and missed his entrance. They later found him hiding, terrified, and he claimed to have actually seen an apparition of some kind. Anderson also once knew a lady who fancied herself to be a bit of a "white witch," and she told him that her young daughter had actually spoken to the ghost once. The ghost had apparently joked to the girl that the best part about being dead was seeing all the shows for free. This spirit also told the girl that in addition to him, there was also a demon in the theater and that people needed to be careful.

Anderson has experienced some paranormal activity at Prescott Center for the Arts himself. On two different occasions while working alone in the theater, he has heard voices in the vestibule that connects the two buildings. There were multiple, indistinguishable voices, like the murmur of a large crowd or audience. There was no one else around on the two times this occurred. There was no radio playing anywhere. He stopped and listened to the murmuring voices both times, and they stopped when he left the vestibule. Later on, a cleaning man for the theater told him that he had experienced this same phenomenon once as well.

Also, once before a performance of Sutton Vane's great play *Outward Bound*, which Anderson had directed, he was sitting alone in the front row of the theater waiting for the cast to arrive. They had a chandelier hanging from the overhead light grid as part of the set, and up high there was a loop in the chandelier's chain hanging loose. He was looking up, just staring into

HISTORICAL MARKER: SACRED HEART CATHOLIC CHURCH AND RECTORY

In the fall of 1878 the Sisters of St. Joseph came to Prescott. Money was raised in the community for a hospital to be run by the sisters and by 1881 the hospital had been completed on North Marina Street. In June 1891 construction was started next door on Sacred Heart Catholic Church. The church was designed by Frank Parker under the direction of Father Alfred Quetu. Fr. Quetu was the prime mover behind the building of the church. The first services were held on February 17, 1895.

Sacred Heart Catholic Church is a substantial brick structure in the "Sober Gothic Style" featuring pointed arches, decorative brickwork and two colors of local rhyolitic tuff stone for trim and the foundation. It is one of the best examples of religious architecture in Arizona. Originally, the church had a steeple 115 feet tall. After being struck by lightning several times, it was removed in 1930. In 1915, the old hospital was torn down and the Rectory was built next door. A new hospital had been built on Grove Avenue in 1898, and the name was changed to Sisters of Mercy Hospital.

June 13, 1969 was the last time the church was used for religious services. In 1969 the Prescott Fine Arts Association acquired the property for a theater and art gallery, an excellent example of adaptation of a historically significant building for re-use for the benefit of the community. The church and rectory are listed in the National Register of Historic Places.

space, when suddenly the loose chain clanked. It was like something had struck the chain, but there wasn't anything. The chain had not shifted. Since he was looking up, this was clearly meant for him to see. Of course, when he started to tell other people, he was laughed at.

According to staff, there is an apparition named Sophie and a little boy dressed in clothing from the late 1800s. One person said that the otherworldly activities are most likely to occur when someone is there alone. She usually experiences these apparitions at least once a week when she's there during the darkness of the early morning hours. She said that she's heard singing upstairs and giggling. The singing sounds like a woman's voice singing old-

time gospel music. She'll find popcorn all the time, although the theater doesn't serve popcorn. She'd heard that one of the late priests liked popcorn a lot.

After one performance, the stage crew was busy setting up the props needed for a bar scene in the next day's show. Two glasses flew up from the table into the air and crashed to the floor. One cleaning lady arrives early in the morning before anyone else is there. In the main theater, she has heard a voice calling her name over and over. When sweeping the dressing rooms out, she has seen her name written in a dust pile by the door.

At the Old Rectory Building, when theater members and performers are trying to get ready for a performance, a rattling noise can often be heard coming from Father Michael's old second-floor room. Every time, people rush upstairs to try to find the source of this noise, which they haven't found yet. Father Michael gets his chuckles and some company as well.

Now known as Prescott Center for the Arts, the site is definitely haunted. Several people have seen shadows move across the upper part of the proscenium. Others have heard a children's choir singing. Scripts have been moved and found in different places. But the most unsettling haunts are by one female ghost that likes to play with the office copier and three male ghosts.

TIS ART CENTER AND GALLERY

Across Cortez Street from the east side of the courthouse stands the Tis Art Gallery, better known as the Knights of Pythias building. Dedicated on November 27, 1895, it stands forty-six feet tall, with three stories, and is the second-tallest building around the Courthouse Plaza, second only to the courthouse itself. According to historian Nancy Burgess, it was originally constructed by local attorneys John C. Herndon, John J. Hawkins and Hugo Richards for their law offices, and it was originally known as the Hawkins-Richards Building. Hawkins later became a prominent judge. A historical marker by the structure claims that it was also called the Tilton building, presumably after prominent local resident Bert Tilton, but at this writing, it is unclear what his participation was.

At some point, the Prescott branch of the Knights of Pythias fraternal lodge moved in and used the third floor as its meeting hall. The Knights still exist, although their numbers have dwindled over the years, and Prescott

no longer maintains a branch. Today, the lodge has about 50,000 members worldwide, although at its peak it once had more than 1 million members.

Formed in Washington, D.C., on February 19, 1864, by Justus H. Rathbone, the Knights of Pythias was reportedly the first fraternal lodge to receive its charter by an act of Congress. Membership requirements, past and present, are open to males who believe in a Supreme Being, do not have political sympathies that favor Communism and are not involved in the distribution of alcohol or drugs (this would seem to disqualify liquor store owners from membership). Each member generally receives a ceremonial sword.

The Knights of Pythias building is one of the few downtown structures that did not burn to the ground during the July 14, 1900 fire that destroyed almost everything. It is unclear exactly

Tis Art Center and Gallery. *Courtesy of Linda Dershem.*

when the Prescott lodge disbanded, but since then, the building has seen a variety of retail uses, including a jewelry store on the first floor in the late twentieth century.

In the early 2000s, the decaying building was purchased by Ann Carson Dater and her daughter, Andrea Smith, who undertook a massive refurbishment of the property. The Tis Art Center and Gallery started a huge undertaking. It had to be restored to the early 1900 criteria, with antique lighting, immaculate wood floors and mahogany-framed glass windows. Although it was impressively restored to a beautiful building, the new owners make sure to keep the bullet holes in the ceiling. A 1920 cash register from the Prescott Depot serves as the till behind the gift counter next to the building's original vault. Today, the Tis Art Gallery is located on the first floor, and law offices are on the second floor. On the third floor, expansive windows overlooking the Courthouse Plaza open up on an eighty-four-capacity banquet hall with a completely furnished kitchen, available to rent for meetings, weddings and receptions. The Tis Gallery

functions as a benefit to the community to help artists having a difficult time getting their work exposed to the public. Charging a low commission to artists allows them to make their work more affordable.

Apparently, some ghosts linger there. Attorneys have almost always had offices in this building; one attorney and his employees said there have been way too many strange things happening that cannot be explained. Another attorney who occupied the second floor several decades ago couldn't get any of his employees to stay late to work on complicated cases. So, he called Father Pyka and asked him to exorcise the place. Father Pyka blessed each floor, said prayers and sprinkled holy water. Things calmed down after that, and the employees were happy and much more comfortable working in the building.

The building sat empty for many years before being purchased. Remodeling started quickly on the building, and the ghosts were soon back in action. A new attorney and his staff moved into the second-floor offices after the remodeling was completed and said they have had plenty of unexplained things happen. Several times a ghostly figure has been seen at the top of the stairs. The new elevator has been known to open by itself. On a weekly basis, the employees find objects in the oddest places. Sometimes papers will just

HISTORICAL MARKER: KNIGHTS OF PYTHIAS BUILDING

With the exception of the Courthouse, the Knights of Pythias Building, also known as the Tilton Building, has always been the tallest building on the Plaza at 46 feet. It was dedicated on November 27, 1895, and is one of the few buildings that survived the fire of 1900. The building originally housed retail on the first floor, office space on the second floor, and a large open hall on the third floor as the meeting room of the Knights of Pythias, an early social fraternal organization attended by many of Prescott's leading male citizens. Scorched in the fire, the front facade was stuccoed and scored to resemble stone. The building was partially restored in 1995.

Funded by the Historic Preservation Fund and the City of Prescott

start fluttering around. A paralegal working there said she saw a ghostly face staring back at her through the second-floor window.

The employees working there today believe that the ghost of Fleming "James" Parker (one of the hanged murderers on the Courthouse Plaza, across the street from Tis Gallery) haunts the building. In 1897, when Parker escaped from jail, he shot and killed Lee Norris, the assistant district attorney, whose offices were located in this building. They believe that Parker is looking for Norris to apologize for what he did. Is Parker opening and shutting the elevator doors searching for Norris? Someone sure is.

Smoki Museum

At 147 North Arizona Avenue, about one mile from downtown, two buildings are constructed of rock, both with an unusual design. They look like very old Native American pueblos and were intentionally designed this way, much like Mary Colter's Watchtower structure at the Grand Canyon.

The building on the left is the Smoki Museum, which helps preserve Native American history and regularly displays Indian artifacts. The building on the right is the Smoki Pueblo, or rather, it used to be. Today, the museum uses it for meetings and community events. Yes, the buildings are haunted, and it is not surprising. The Smoki has a past that is rife with controversy, and bad feelings still exist in Prescott regarding its existence.

It all started in 1921, when Prescott's famous Frontier Days Rodeo, which had been held yearly since 1888 (and is still held) was low on money and the possibility of its closure was very strong. A group of local businessmen got together and decided on a fundraising venture to save the rodeo: a variety show with an Indian theme. Advertising it as the "Way Out West Show," the white performers dressed as Indians, did mock Native American rituals and dances and played mock Native American music. While this sounds appalling in today's era, this was a much different time—a time when blackface minstrel shows and other ethnic impersonations were popular in entertainment.

The show was a huge success among Prescott residents and made enough money to keep the rodeo going. It was successful enough that the show's producers decided to do it again…and again. They were having fun, after all. By 1923, the group of businessmen turned performers had adopted the name of the Smoki People and had persuaded no less than Prescott's famed

Smoki Pueblo. *Courtesy of Darlene Wilson.*

poet and historian Sharlot M. Hall to write a fiction booklet about the origin of the mysterious Smoki tribe.

The Smoki People very quickly became a fraternal organization, right down to initiation ceremonies and rituals, secret meetings and community and charitable involvement. But once a year, the group would perform the show, dressing as Indians and performing Native American dances, particularly the sacred Hopi snake dance. In advance of the show, the Smoki would pay children to go out and catch snakes for them to use in the performances. The Smoki began to research Native American rituals so they could perform them accurately.

Naturally, this did not sit well with Native American tribes, particularly the Hopi, whose sacred dances dominated the Smoki shows, which had become so popular they were even drawing tourists. The tribes protested for many years, but the Smoki responded that they were helping preserve the culture of what was perceived at that time to be a vanishing race, so they kept doing it. This is what has been difficult for modern-day historians to comprehend—the white Smoki sincerely believed they were honoring the Indian tribes, even as the tribes themselves were asking them to stop it.

In 1935, the Smoki, now a fraternal lodge, built the museum and pueblo with the help of the Civilian Conservation Corps. The museum displayed artifacts, while the "pueblo" was where lodge members held their secret meetings. By this time, the Smoki had become a powerful force in Prescott culture and politics. For men in the city, if you weren't a Smoki, you weren't anything. Prominent local figures had joined the Smoki People, and perhaps their best-known member was U.S. Senator and 1964 presidential candidate Barry M. Goldwater. Photos still survive of Goldwater in his Indian regalia.

The years and the decades marched on, with the Smoki continuing their yearly performances, which had grown very elaborate. By the 1970s, other ethnic impersonations (such as minstrel shows) had fallen out of favor in changing times, but the Smoki continued on, despite increasingly vocal protests from the Hopi and other tribes, whose influence was growing in the Southwest.

Incredibly, the Smoki people soldiered on through the 1980s, performing their yearly Indian show, despite dwindling lodge membership and increasingly angry tribal protests. It all came to a head in 1990, when the Hopi tribe descended on Prescott to stage a large in-person protest of the Smoki show. This would be the last time the Smoki performed. Following the 1990 show, the lodge agreed to end the yearly spectacle. Without this mainstay, the lodge itself foundered, and it officially disbanded a few years later. They had lasted more than seventy years.

But the Smoki Museum still exists, operated by people unaffiliated with the old lodge. They have tried to mend fences with Native American tribes by respectfully depicting tribal histories and artifacts under the advice and input of tribal leaders. The Smoki Pueblo, where lodge members held their secret fraternal meetings, is now used to host business gatherings and meetings for a variety of Prescott organizations.

Needless to say, bad feelings still exist. The Hopi tribe remembers how the Smoki cribbed their sacred rituals for entertainment and profit. Meanwhile, there are still some former Smoki members alive yet, many of them bitter over what they perceive as "political correctness run amok" in the destruction of the lodge. Still loyal to the disbanded fraternity, they still will not reveal to historians what the Smoki's secret rituals, including the initiation ceremony, consisted of.

With such a controversial background, it is no wonder the Smoki "campus" is haunted. Museum staff members often report sensations of being touched when no one is around. Sometimes they feel a breeze when there is no wind. These sensations have been reported in both buildings.

Lights have mysteriously turned on and off as well. It would seem some of the old Smoki members are still hanging around.

Smoki staff have noted that they believe one of the ghosts is Barry Goldwater himself. The famed U.S. senator joined the Smoki in 1941 and was the announcer for many of the shows. He also specifically performed in 1941 and 1947.

In 2013, the Smoki Museum produced an exhibit called "Arizona's Son: The Photography of Barry Goldwater." The senator had been an amateur photographer much of his life, and there has been much latter-day interest in his photos. Staff and museum volunteers framed nineteen photos and hung them in the museum the night before the grand opening. The next morning, the museum director discovered an act of what appeared to be vandalism, but there was no sign of forced entry, nor had the security alarms gone off. Eighteen of the nineteen photos had crashed to the floor, shattering the glass in each one of them. There was no logical explanation for this event. Staff quickly reframed the photos, minus the glass, so the exhibit could open on time. It was speculated that Barry Goldwater's spirit had done the damage. As a rule, photographers dislike having their photos framed with glass. Could the senator's spirit have been making a statement about this?

There is also a report that at one point in recent years, a Native American group attempted to perform a ceremony with sage, cedar and prayers to cleanse the Smoki Pueblo building of spirits. During the ritual, lights started flashing on and off by themselves. Staff members believe that the spirits remain.

Fort Whipple Museum

Established in 1864, Fort Whipple was a tactical base for the U.S. Cavalry during the Indian Wars of 1864–82. Fort Whipple is still here today as a museum, located on the grounds of the Veterans Administration Hospital. But before arriving at the present location, more than 150 years ago, the first governor arrived in Del Rio Springs (Chino Valley, Arizona) to establish the territory's first capital. Although temporary, Del Rio played an important part in the development of Arizona.

By 1895, the site had become dilapidated, and two years later, it was scheduled for deactivation. The United States declared war on Spain in

Fort Whipple Museum. *Courtesy of Darlene Wilson.*

1898, and two hundred troops were sent east to the Spanish-American War. New buildings were constructed in 1905, and five hundred soldiers moved in. After Arizona became a state in 1912, the place was deserted except for a maintenance crew. In 1918, during World War I, Fort Whipple was reactivated as a hospital for respiratory illnesses and soldiers injured by nerve gas. In 1931, it was transferred to the Veterans Administration.

Fort Whipple is a vital part of Prescott's (and the United States') history. At one time, it was considered Arizona's territorial capital. Fort Whipple has been many things throughout the years, but it's always been a military base of some kind since 1864. One of the military quarters is now Fort Whipple Museum, part of the Sharlot Hall Museum. The museum has artifacts about the fort and hospital. There is history of the Buffalo Soldiers, maps, photographs and letters written by those stationed there. The museum is operated as a joint project of the Shalrot Hall Museum and the Bob Stump Veterans Affairs Medical Center.

The museum stands out from the other buildings at the VA Medical Center. It is the only building with the original color scheme historically accurate at the time, when all the buildings were painted green and yellow. Back in the day, the fort was the information and entertainment center of Prescott. Telegraph dispatches were received at the fort, and the first experimental telephone was installed there in the 1870s. After the Great Fire, the fort ovens were made available so bakers could supply the community with bread.

Once a month, local reenactors stage a living-history presentation in and around the museum with traders, miners and soldiers. The ghosts that haunt the museum are believed to be some of the Buffalo Soldiers. The Buffalo Soldiers arrived at Fort Whipple in 1885. The black troops reported for duty in Arizona at Fort Whipple. Their stories are on display at the museum. The soldiers once entertained the troops and were well received in Prescott. Do you suppose the soldier that haunts the museum is one who played in the band?

The other ghost that has been heard in the museum is believed to be that of a colonel's daughter. She lived there with her family and mesmerized all the young troops at Fort Whipple. Women were scarce in Prescott back then, especially women like the colonel's daughter. Her dance card was always filled, but the men never knew where they stood with her. She could be sweet and charming one minute and cold and distant the next. She was the belle of the ball and haunts the museum now, looking for that attention again—to be the star of the evening.

CEMETERIES

As a community dating back to 1864, Prescott has a number of very old and unique cemeteries. In recent times, full casket burial of the dead has started to fade in America and throughout much of the world, thanks largely to the increasing popularity of cremation to dispose of the mortal remains of the deceased. But throughout most of history, this was not the case, and even most small towns have at least one cemetery. Cemeteries are often reputed to be haunted, and most people try to avoid crossing them at night to this day. Even though Prescott's cemeteries do not, for the most part, have any specific ghost lore attached to them, a few of the oldest ones tend to evoke an eerie feeling regardless. These are Prescott's most significant burial grounds.

CITIZENS CEMETERY

The oldest cemetery in Prescott is Citizens Cemetery, located roughly half a mile from downtown on Sheldon Street. The first burial here was in 1864, the same year that Prescott and the Arizona Territory were formed. In the early days, this location was out in the country, but not anymore.

The first man to be interred here was Joel Woods, a Colorado state legislator who was apparently visiting; he was killed in a hunting accident on June 1, 1864. It is no longer known why he was buried in Prescott instead of

being shipped back home, and the location of his grave is no longer known. There are many unmarked graves among the roughly 2,700 burials here; some of their identities are known through an old cemetery map, but many graves are truly unknown.

Burials ended here in 1933, after the cemetery had reached capacity. A very small number of later graves exist because the deceased had purchased the plots earlier, and there was one incident in the 1990s where someone snuck in by night and buried a man's cremated remains in the grave of his ancestor without permission (he is still there).

Owned by the County of Yavapai, Citizens Cemetery had become largely neglected, overgrown with weeds and vandalized in the latter part of the twentieth century. Disturbed by this, local resident Pat Atchison formed a group in 1994 called the Yavapai Cemetery Association for the purpose of restoring and caring for Citizens Cemetery. Under an agreement with the County of Yavapai, Mrs. Atchison and her group's members worked laboriously to clean up Citizens Cemetery, and they continued to care for it for many years, even after Mrs. Atchison's retirement from the group due to health reasons. Her successors, led by Julie Holst, worked just as hard at maintaining Citizens Cemetery. Sadly, for a variety of reasons, the Yavapai Cemetery Association disbanded in the summer of 2018, and upkeep of Citizens Cemetery was returned to the county.

Many significant Prescott and Yavapai County pioneers are buried here, including miner and rancher Charles Genung, who forged some of Yavapai County's first roads using hired Native American labor. U.S. Marshal Crawley P. Dake is buried here as well; he was the man whose appointments sent the Earp brothers to Tombstone and infamy.

Speaking of the Earps, the ex-wife (Victoria) and eight-year-old daughter (Henrietta) of Earp enemy John Behan are buried here. So is William Partridge, whom Arizona legend contends was tricked by mining "boss" Charles P. Stanton into murdering a stage stop owner in the southern part of the county.

Union Civil War general William Henry Harrison McCall, who retired to the Arizona Territory after being mustered out of service, is interred here as well. So is former Prescott mayor Dennis Burke, who built the haunted St. Michael Hotel. The Roman Catholic priest Father Edmond Claessen, whose ghost is believed to haunt the Prescott Center for the Arts theater, is buried here, and his grave was recently given a new marker by concerned historians. Also, silent film actor William Lambert is known to be buried here, but the location of his unmarked grave is no longer known.

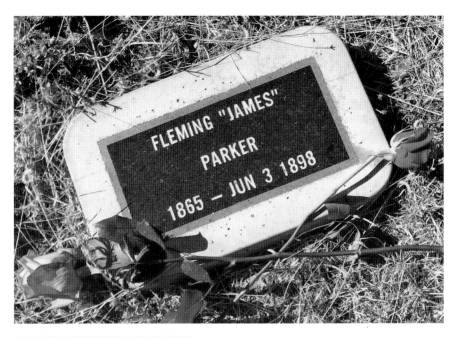

Above: Fleming "James" Parker's headstone. *Courtesy of Patti Ortiz*.

Left: Paying respect at Citizens Cemetery. *Courtesy of Darlene Wilson*.

Although the locations of a few of them are not known, it is virtually certain that ten of Prescott's eleven hanged murderers are buried here in unmarked graves. The cemetery map shows four of them buried side by side—Dennis Dilda, Fleming Parker, Hilario Hidalgo and Francisco Renteria—in the potter's field section where indigents and other undesirables were buried at county expense. In 2016, coauthor Anderson and members of the Ruffner family—descendants of the sheriff who hanged Parker—arranged for a marker to be placed at Parker's grave. Out of all these murderers, he is the only one whose story can elicit any sympathy at all, and he should have been charged with second-degree murder instead of murder in the first degree.

Anyone interested in the history of Prescott should make Citizens Cemetery one of their first stops.

HISTORICAL MARKER: CITIZENS CEMETERY

Citizens Cemetery was founded in early June 1864 with the burial of Colorado legislator Joel Woods. Established on public land east of Prescott and southwest of Fort Whipple, the cemetery has been known at various times as "Town Cemetery," "City Cemetery," "Prescott Cemetery," and "Citizen's Burying Ground." The name "Citizens Cemetery" first appeared in print in January 1872. The United States deeded the land to Virgina Koch in 1876. After her death, it was purchased by T.W. Otis and George Tinker and their wives. On October 13, 1884, the land was transferred to Yavapai County. Burial lots were "leased" for 99 years at a cost of $2.50. Interments continued on a regular basis until 1933. The cemetery contains the graves of more than 2,500 persons and approximately 600 markers. Citizens Cemetery is populated with a wide spectrum of individuals who settled and developed central Arizona during the late 19th and early 20th century. In 1934, a Civil Works Administration project resulted in the construction of an uncoursed fieldstone and concrete masonry wall which enclosed the 6-1/2 acre cemetery. By that time, the entrance to the cemetery had been moved from the south end to the north end. Later, the north wall was demolished for the widening of Sheldon Street. A new stone wall topped by a fence and a new entry were construction in 2000. Citizens Cemetery is listed in the National Register of Historic Places.

Funded by the City of Prescott

MASONIC CEMETERY

Prescott's Masonic Lodge, Aztlan Lodge No. 1, is the first branch of Freemasonry to have been formed in Arizona. It held its first meeting in the Governor's Mansion itself in 1864, with territorial governor John N. Goodwin presiding.

The lodge maintains its own cemetery in Prescott, located at the top of Fleury Avenue, across from Sharlot Hall Museum and next to the "new" Sacred Heart Catholic Church (very ironic, since Catholics and Masons were blood enemies throughout much of their existence in world history). The land for this cemetery was deeded to Aztlan Lodge No. 1 by territorial secretary and later Justice of the Peace Henry W. Fleury. For his generosity, Fleury was allowed to be buried here upon his death in 1895, even though he was not a Mason.

The Masonic Cemetery is surrounded by a fence and a locked gate. You cannot visit this cemetery without permission from the lodge, although you can look over the fence from the outside. Notable burials here include former Prescott mayor Morris Goldwater, founder of the old Goldwater store chain in Arizona and uncle of legendary U.S. Senator Barry M. Goldwater. Also interred here is Thomas Marshall Jones, a Confederate colonel from the Civil War, who died in 1913.

IOOF CEMETERY

The Independent Order of Odd Fellows (IOOF) is a fraternal lodge that has been traced back to 1730 in Great Britain. Its influence was once very great across the United Kingdom. Its first chartered lodge in the United States came in 1819, and the group rapidly spread across America, establishing lodges in most larger cities and many smaller ones. At its peak, the Odd Fellows order was so large that it established its own cemeteries for its dead, just as the Masons had done.

The lodge still exists in America, but numbers have decreased considerably in later years, with many local lodges closing their doors. The Odd Fellows are even more secretive than many fraternal organizations and usually do not even acknowledge or respond to requests from historians for information on their members from bygone eras.

IOOF Cemetery. *Courtesy of Darlene Wilson.*

The Odd Fellows Cemetery in Prescott is at the south end of Virginia Street, adjacent to the J.S. Acker Park, about one mile or so from downtown. The Prescott IOOF Lodge no longer exists, and it is unclear at this time when it left Prescott. Its cemetery is under other ownership now and is still in use, although, needless to say, new burials are no longer IOOF members.

Notable burials here include Lewis Wolfley, former territorial governor of Arizona. Also buried here is Benjamin Belcher, the first manager of the Elks Opera House, who committed suicide a few years after leaving the post. English expatriate miner Thomas Gibson Barlow-Massicks is buried here. He had mining interests along Lynx Creek and had a small town named for him. The town of Massicks, Arizona, is long a ghost town, and in fact, there is nothing left of it—not even any ruins. Mr. Barlow-Massicks died of injuries suffered in a freak accident in 1898 when he accidentally dropped his gun, which discharged, shooting him.

PIONEERS' HOME CEMETERY

The Arizona Pioneers' Home is a nursing home for the elderly and infirm and is owned by the State of Arizona. Established in 1911, when Arizona was still a territory, it is one of only two state-owned nursing homes in America. There are strict requirements for admission, the most notable being that you have to have lived in Arizona for at least fifty years.

The Pioneers' Home Cemetery is located on a hillside off Iron Springs Road, nearly three miles from downtown Prescott and not far from Mountain View Cemetery. For most of its existence, it was only utilized for the burials of inhabitants of the Pioneers' Home. In very recent years, this policy changed due to a shortage of cemetery space in Prescott, and now anyone can buy a plot and be buried here.

Buried here is Mary K. Cummings, better known as "Big Nose Kate," a lady friend of gunfighter Doc Holliday's. Her grave is constantly covered with flowers and mementos, left by "Wild West" aficionados. At the very top of the hill is the grave and family plot of historian and poetess Sharlot M. Hall, the founder of the museum that bears her name in Prescott. Buried next to Sharlot Hall is famed painter and photographer Kate Cory.

There are two men buried here: Henry Street Smith, who claimed to be Billy the Kid, and John Miller, who did not but is believed to be the real Billy the Kid nonetheless.

Big Nose Kate's headstone. *Courtesy of Darlene Wilson.*

The most notable graves of nonresidents of the Pioneers' Home are in the newer part of the cemetery. The memorial to the Granite Mountain Hotshots is visited every day by people. The Hotshots were an elite firefighting unit that made world headlines when nineteen of their twenty members died at one time battling the Yarnell Hill Fire in 2013. Their memorial here is beautiful, with markers and grave sites laid out for all nineteen deceased firefighters. But in reality, only ten of them are actually buried here, leaving some visitors wondering which ones are resting here and which aren't.

PRESCOTT NATIONAL CEMETERY

Prescott National Cemetery is one of America's military cemeteries, and veterans from many wars who had retired to Yavapai County are buried here. The cemetery is located at the intersection of Highways 89 and 69, roughly two miles east of downtown Prescott.

The cemetery was closed to full burials in 1974, when it ran out of space, but cremated remains can still be interred in the columbarium here. One exception was made in 2014, when the remains of soldier Herbert V. Young Jr. were discovered in a remote section of what once was New Guinea, where he had been shot down in a fighter plane during World War II. Long considered MIA, his remains were returned to Prescott, where he was given a full casket burial with a military service at

National Cemetery entrance. *Courtesy of Darlene Wilson.*

Prescott National Cemetery. Also buried here is Nicholas Foran, a Medal of Honor recipient for his service during the Indian Wars; he died in 1927.

MOUNTAIN VIEW CEMETERY

Prescott's largest cemetery was opened for business in 1911, located along what is today Willow Creek Road in what once was known as Miller Valley, about two miles from downtown Prescott. Many notable Prescott citizens are buried here, and although the cemetery is well cared for, some visitors believe this place gives off an uneasy feeling. While reports of paranormal activity are rare, some have come away wondering if it might exist in Mountain View Cemetery. Yavapai County's only mausoleum is located here as well, although it is kept locked and you have to get permission to enter it.

Mountain View Cemetery, with Thumb Butte in the background. *Courtesy of Darlene Wilson.*

Notable burials here are legion and include U.S. Senator Henry F. Ashurst and Arizona governor Thomas Campbell. Also, John Goulder Campbell and John W. Wilson, both of whom served as territorial delegates to the U.S. House of Representatives before Arizona statehood, are buried here.

Actress Dorothy Fay Southworth Ritter (billed as just Dorothy Fay in her few screen appearances in the 1930s), who gave up her career when she married country singer Tex Ritter, was buried here in her parents' family plot when she died in 2003. It is unclear why she was not interred next to her husband in Texas. She was the mother of actor John Ritter, who was best known for the *Three's Company* TV series.

Dwarf actress Ruth Duccini, who was one of the last surviving "Munchkins" from the classic 1939 film *The Wizard of Oz*, passed away in 2014, and her cremated remains were inurned in the columbarium in Mountain View Cemetery.

Veteran Richard Longstreet Tea, who was a Medal of Honor recipient for his service during the Indian Wars, was buried here upon his death in 1911, when Mountain View Cemetery was quite new. Legendary Yavapai County sheriff George C. Ruffner, who oversaw the hanging of the outlaw Fleming Parker, is buried here as well, along with many members of his family.

Above: Potter's field headstone mass grave. *Courtesy of Darlene Wilson.*

Right: Medal of Honor recipient. *Courtesy of Darlene Wilson.*

Adjacent to Mountain View Cemetery is the Yavapai County Cemetery, or the potter's field, where the county buries or inurns the indigent at county expense. In this cemetery is also a large mass grave containing the remains of more than eight hundred corpses, exhumed in the 1960s from the previous county-owned cemetery to make room for the new Prescott High School, which was to be built on the site. This has long been a problem in America, as developers tend to cast an eye on old cemeteries when they are looking for land to develop.

ROLLING HILLS CEMETERY

Although not in the city limits per se, Rolling Hills Cemetery is considered to be a Prescott cemetery. It is located near the Prescott Airport on Ruger Road about seven miles from downtown. It is in largely derelict condition. It was opened in the 1930s as a "low end" cemetery so people with smaller incomes would have a place to bury their dead instead of the "nicer" cemeteries in town. Rolling Hills Cemetery was closed to burials circa 1956.

There is reportedly a mass grave here, consisting of four rows of burials exhumed from Citizens Cemetery when Sheldon Street was widened around the 1960s. While there is no marker here signifying the presence of a mass grave, there certainly is room for one inside the grounds.

YAVAPAI TRIBAL CEMETERY

This is the one cemetery you will likely never visit. It is located inside the Yavapai Indian tribe's reservation in Prescott, and you cannot visit it without the tribe's permission, which is not always forthcoming. Indeed, non-members of the tribe are not allowed to go onto much of the reservation at all without, at a bare minimum, an invitation from a member of the tribe who lives there.

Some years back, while doing some research on the life of former Yavapai chief Viola Jimulla, coauthor Anderson requested permission from the tribe to pay his respects at her grave. It was granted with the stipulation that he not take any photos of the cemetery (it is virtually universal that Native American tribes frown on photos being taken of their burial sites). Upon

arrangement, two men picked him up and took him to the cemetery. It is a very nice place and well kept up. When he finished his visit, the men took him back where they found him.

Cemetery Etiquette When Doing a Haunted Investigation

The greatest respect should be given when investigating any cemetery. Cemeteries are quiet and solemn places with specific rules. For some, this is their home. Be aware of what is said; there should be no joking or inappropriate or offensive language. It's important to walk the cemetery before you start your investigation, before you even start taking pictures. Hold off until you have walked the cemetery and asked for permission to be there.

If you are doing an evening investigation especially, make certain to get permission from the organization in charge of the cemetery. You may have to sign waivers and supply the names of everyone doing the investigation. Do not touch the memorials, headstones or artefacts. Do not bring children or pets. Do not litter, eat or smoke.

Always investigate in pairs so someone can validate occurrences and log information. Having someone with you helps to back up your claim and gives you and the experience credibility.

Never dare or threaten a spirit. Remember to always show respect to the ghosts, property owners and others on the investigation.

IN CLOSING

This book is not the last word on Prescott hauntings. We are aware of a number of homes that have spirits attached to them as well, but have not included these because they are private residences. We have also omitted one very prominent and well-known haunted site out of respect and consideration for the family of the individual whose spirit it supposedly is, as they are very upset by the ghost stories. In paranormal phenomena, occasional isolated incidents occur as well, perhaps caused by spirits who are just passing through—coauthor Anderson lives in an apartment building where one of his neighbors became frightened once upon hearing mysterious weeping in her unit, seemingly coming from nowhere. This was a one-time occurrence and nothing further has happened to date. We have generally not included such isolated phenomena.

Prescott is surrounded by beautiful scenery and mild climate, and people retire here every year, causing the population to continue growing. With Prescott's haunted history, it is certain that more incidents such as reported in this book will continue in these locales. So, if you move here or visit, and feel a cold chill or someone tapping you on the shoulder when no one is around, don't be alarmed. Prescott's spirits seem to be friendly and harmless, if a bit mischievous. Happy hauntings!

About the Authors

Parker Anderson is an Arizona native and a recognized historian in Prescott. He has authored the books *Elks Opera House*, *Cemeteries of Yavapai County*, *Grand Canyon Pioneer Cemetery* and *Wicked Prescott* for Arcadia Publishing/The History Press. He has also authored a number of Arizona history plays for Blue Rose Theater.

Darlene Wilson has been involved in the paranormal world for more than forty years. She has worked with the police in Colorado on several cases before experiencing her own ghostly encounter at the Stanley Hotel in 1989. She is owner and tour guide for A Haunting Experience Tours and Prescott Tour and Tastings and organizer of the September 13–14, 2019 Prescott Paranormal Expo.